*~ In Posse ~*

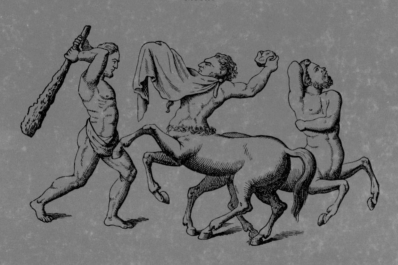

PUBLISHER'S NOTE ON THE FIRST EDITION

*It is observed that the presentation herein is consistent with that established as concerning*

THE Unflown Visual Arts AND Crafts GUILD.

In this instance CURATED *and* DESIGNED *by* Jacob Covey.

TEXT EDITED *by* Karin Snelson.

WRITTEN *by* Heidi Broadhead, Felicia Gotthelf, Paul Hughes, *and* Rob Lightner.

Promotional Ballyhoo provided *by* Mr. E. Reynolds.

*All contents are within the purview of*

Gary Groth *and* Kim Thompson, Esteemed Publishers.

*And better had they ne'er been born,*
*Who read to doubt, or read to scorn.*
*—Sir Walter Scott*

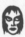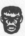

The Fantagraphics Books office building is located at 7563 Lake City Way N.E. in Seattle, Wash., 98115. BEASTS! is © 2006 Fantagraphics Books, Inc. All images are copyright © 2006 the respective artist while all text is copyright © 2006 the respective writer. All rights reserved. Permission to reproduce material must be obtained from the artist, author, or publisher.

"Mystery of the Sea Hog" is excerpted from LUBA: THREE DAUGHTERS, Volume 23 in the LOVE & ROCKETS Collection by Gilbert and Jaime Hernandez. Please note that it is the only artist piece that is not unique to this bestiary. Daniel Taylor's interview was generously transcribed by Stephen Hirsch who suffered through a poorly recorded cassette of painful distortion to do so.

The Designer notes that the softcover editon will vary from the hardcover printing primarily in the paper stock used. For the softcover edition, a matte gloss coating will allow more contrast to the art and sacrifice the tactile qualitites of the original uncoated paper. This will also make the fifth color, Pantone 873 (Gold), more striking throughout the book. The Curator (who is, of course, also the Designer) apologizes for any omission of information due to his own difficulty with organizing such a large project that seemed like an easy enough thing at the time he suggested it. All errors will be rectified to best effect in the third edition if a surprising demand for such should present itself.

To receive a complimentary offset-printed catalog of comics, graphic novels, and other related materials, please call 800.657.1100 from your telephone, or tour www.fantagraphics.com anywhere you find the Internet.

First Fantagraphics Books softcover edition (third printing overall): November 2008, exactly two years after the first hardcover edition.

Distributed in the U.S.A. by WW Norton (212.354.5500); in Canada by Canadian Manda Group (416-516-0911); in the U.K. by Turnaround Distribution (208.829.3009). Interdimensional rights available by contacting the publisher.

ISBN13: 978-1-56097-950-0
Printed in Singapore.

When visiting "The Jet City," make plans to stay in the historic Georgetown District where you can enjoy the well-stocked Fantagraphics Books emporium storefront.

Finally, we would like to point out the pages of this book are removable when used in conjunction with a sharp knife blade or a sudden jerking motion. These pages would be attractive when framed and hung upon your walls.

# THE *NEW* MODERN NOW LIBRARY SERIES

## PART THE FIRST

---

*A PRODIGIOUS BESTIARY*
*from the* INTEREST *of* MODERN ARTISANS

---

# BEASTS!

---

A PICTORIAL SCHEDULE *OF*

TRADITIONAL HIDDEN CREATURES

*as Curated by Jacob Covey, A.D.*

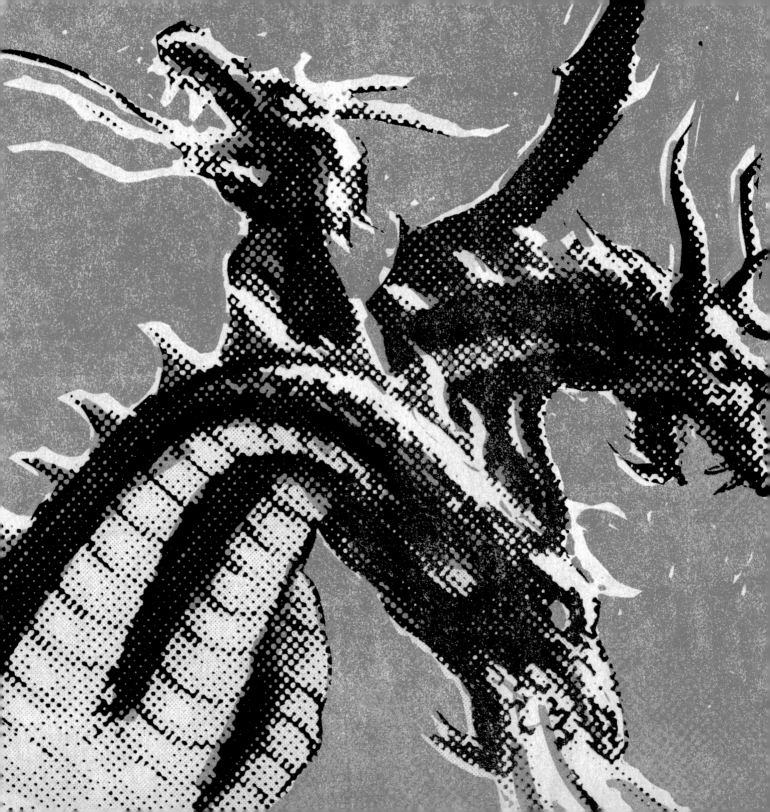

Plate 01 . Japanese Movie Poster . UNKNOWN

*THERE ARE MANY INTERESTING THINGS CONCERNING THIS BOOK AND AMONG THEM ARE THESE:*

The *ARTWORK.* The artwork was solicited from artists working in the disparate worlds of comics, rock posters, skate graphics, fantasy illustration, pin-ups, children's books, animation, and commercial and gallery art. The artists were invited to contribute with no limitations put to them beyond depicting the creature based upon the historical record of it. The artwork runs here without any approval process or editing on the part of the publisher.

The *SELECTION.* As the artists were added to the book, they were given a list of approximately 200 brief descriptions of creatures culled from the Curator's readings. (Additionally they were welcomed to suggest others, which some few did.) From this list artists selected the Beast they wished to depict and, with this knowledge, it is perhaps enjoyable for the reader to consider each artist's choice of myth in the context of that artist's work as a whole.

The *APPROACH.* Because all of the artists were asked to be a part of this book based solely on the quality of their work, their approach to communicating each Beast is unique to them. While mermaids and unicorns are well known, most of these creatures are not, and before the submitted art there was no visual reference to be found. The result here is the depiction, essentially, of the artist's own response to the story of his or her Beast. The enthusiastic reader may find it a rewarding task to read through the descriptions before viewing the artwork.

The *CREATURES.* All of the creatures herein abide by one rule only. They are each a part of mythological or folkloric storytelling. These creatures originate not as entertaining images, nor as an individual's story, but as cultural entities, whether still thriving or long extinct. It is the Curator's hope that the reader will consider this while viewing the pieces, which are admittedly, in and of themselves, remarkable and deserving of undivided attention.

*FACTS:* The first pieces submitted were by Jesse LeDoux and S.britt almost immediately and on the same week, in August 2005. The last arrived the following June. It was by the reliable if tardy Jordan Crane. Very few artists, perhaps ten, politely declined the request to contribute. Three were obliged to eventually opt out due to outside demands. And only one artist, having vanished without a word, left an anxious, though temporary, gap in these pages.

*CONSIDER:* The Kraken is a legendary sea monster populating the lore of sailors. Described as a vicious, multi-tentacled behemoth, its arms are capable of reaching the tops of the highest ship masts and splintering hulls effortlessly. Their sheer enormity has led to them being discounted but they are likely found in more manageable sizes as the giant squid, which is still fearsome at up to forty-five feet long. One of the few recovered specimens was discovered after one of the titanic battles they are known to have with sperm whales. An expired whale was found floating in open water, choked by dismembered tentacles that remained clinging about its throat. The severed head of its nemesis was found in its stomach.

*NOTE:* The face that appears on the spine of this book illustrates the Vampire. It is by Keith Shore and appears in the Tiny Showcase print set.

**FANTAGRAPHICS BOOKS**

NINETY ARTISTS, FOUR AUTHORS, AND ONE EDITOR have generously and zealously made this book not only possible but a thing of greater beauty than the Curator had dared to imagine when the project began in the spring season of 2005. This book is more beautiful, even, than the experienced imaginings of the agreeable but quietly dubious publisher whom we hope will see a favorable return on this faith. Such group munificence seems to reflect the deeply important nature of these cryptids and the cultural stories that come with them.

These Beasts seem to manifest the very creative impulse, a fire in the belly stoked by both human anxieties and the fantastic imagination. For this reason the Curator sees great value in documenting these creatures whose terrestrial intangibility seems inconsequential to their presence as ideas, as feared and revered entities.

Inspired symbology or undocumented fauna, they exist because they are believed in, and these artisans have given them exceptional hides for the hunting.

*The Curator of the New Modern Now Library Series, Jacob Covey, may be contacted through either the Fantagraphics Books Publishing Company or the Unflown Visual Arts and Crafts Guild. Browse www.fantagraphics.com and www.unflown.com for information on further and future projects which may interest even the most indifferent reader of BEASTS!, the first title in this completely unplanned series.*

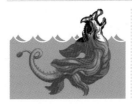

*Cryptozoology* is "the study of hidden animals." It is a disputed branch of science populated by elusive creatures both presumed to exist, such as the Colossal Octopus, and those largely held not to exist, such as the Sasquatch or Leviathan. These creatures are referred to as *cryptids.*

JACOB COVEY WISHES TO THANK PEOPLE. Those people include Jacob McMurray for Resolute Support surpassed only by Sandy and Perry Covey. General and Specific Gratitude is due Angela Kongelbak, Shane Huddleston, Meghan Thompson, Aaron Roeder, Dave Crider, Jason Irwin, Joe Newton, Alex Chun, Alan Mooers, Nick Sgambelluri, Adam Grano, and BORN MAGAZINE's Gabe Kean.

THANK YOU FOR BUYING THIS BOOK.

Thank you Jesse LeDoux, S.britt, Art Chantry, Joe Vaux, Richard Sala, and Dave Cooper for quickly creating inspiring artwork for a project that barely existed. These gentlemen in particular motivated this armada of artists to believe BEASTS! deserved their unhindered attention. Many, many of the contributors herein redirected demanding schedules to participate. All continued to submit superb work to a project inevitably steeped in friendly rivalry and so kept the bar raising ever-higher. They are greatly appreciated. For reasons of abundant generosity, gratitude is owed Steven Weissman, Jordan Crane, Jay Ryan, Keith Shore, Dan Grzeca, Heiko Müller, Jason Robards, and the eminent Tony "I'll-Come-Over-There-And-Pound-Your-Head-In" Millionaire.

A number of artists are to be further thanked in advance for their help in the form of laborious book signings and contributing to the gallery exhibition. Likewise, thanks to Jon B., Shea'la, and the ten artists creating all-new work for the simultaneous release of the limited edition box set through Tiny Showcase, including Saelee Oh who does not appear here.

Thank you to 826 Seattle and the generous Heidi Broadhead, Felicia Gotthelf, Paul Hughes, and Rob Lightner. It will be noted that these writers have contributed immeasurably, forgivingly, and, for reasons not to be elaborated upon here, plying their trade completely under deadline duress. Furthermore, Karin Snelson transformed the text of this book, caught innumerable oversights, and genuinely performed miracles of editorial application. She did this in just three weeks time.

Daniel Taylor and Marvin Kirschnik graciously shared their stories, giving this book a form it would not otherwise have. Thanks also to Linda Fuller and Ms. Teri Hein.

This NEW MODERN BESTIARY, such as it is, is primarily the result of Gary Groth and Kim Thompson with their lifelong passion for relevance in the illustrative arts, along with Eric Reynolds, Greg Zura, Kristy Valenti, John DiBello, and the Fantagraphics Industry. Ancillary gratitude is due all supporters of independent publishing, most especially the remarkable Jeannie Schulz for her faith in this publisher to do justice to the legacy of the PEANUTS comic strip her departed husband crafted so marvelously.

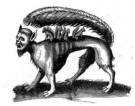

THIS BOOK IS DEDICATED WITH LOVE TO ELIZABETH DEAN, THE MOST BRILLIANT OF BELIEVERS.

# Contents, in Order of Appearance.

# Contents Continued.

FANTAGRAPHICS BOOKS

# The American Buffalo

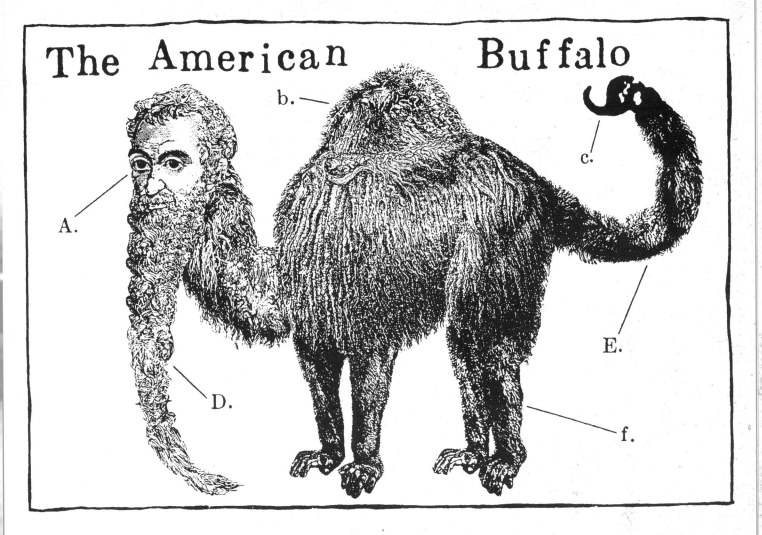

A.

b.

c.

D.

E.

f.

## 𝔄merican 𝔅uffalo

When early European travelers came to the New World and wrote about their findings, they understandably drew from their existing points of reference. One early explorer recorded in his journal the fantastical new beasts he witnessed with "the hump of a camel, the tail of a scorpion, the fur-covered legs of a monkey, and the great eyes and long beard of a Spaniard." He was describing the American bison—a **BUFFALO**.

Plate 03 . The American Buffalo . ART CHANTRY

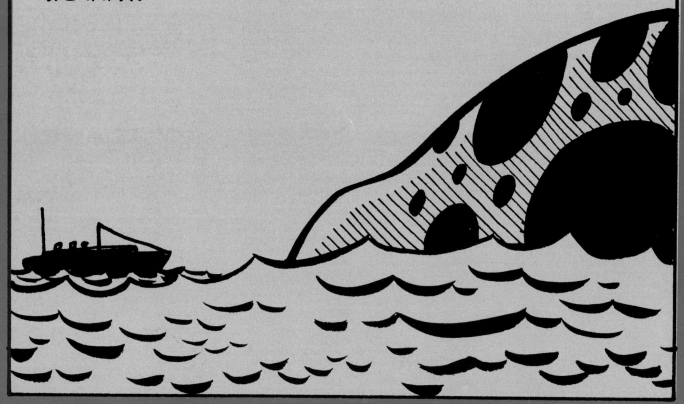

Plate 02 . Mystery of the Sea Hog . GILBERT HERNANDEZ

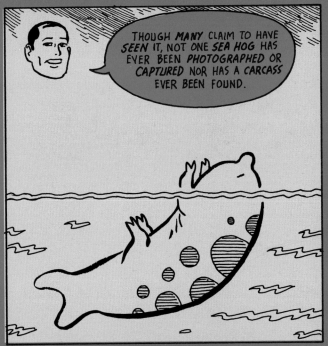

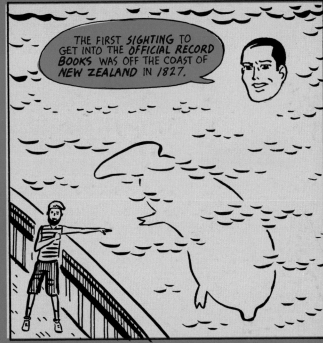

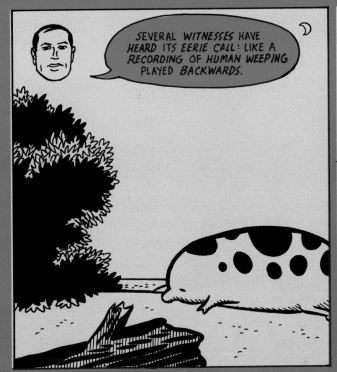

**BEASTS!**

Plate 04 . Beast of Bray Road (Eyewitness Close-Up) . MARVIN KIRSCHNIK

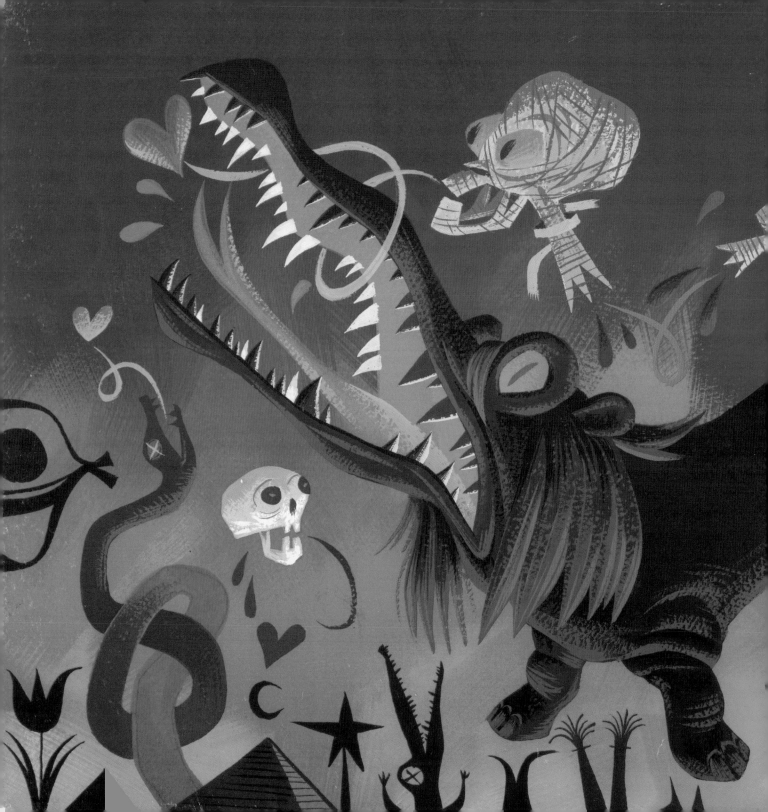

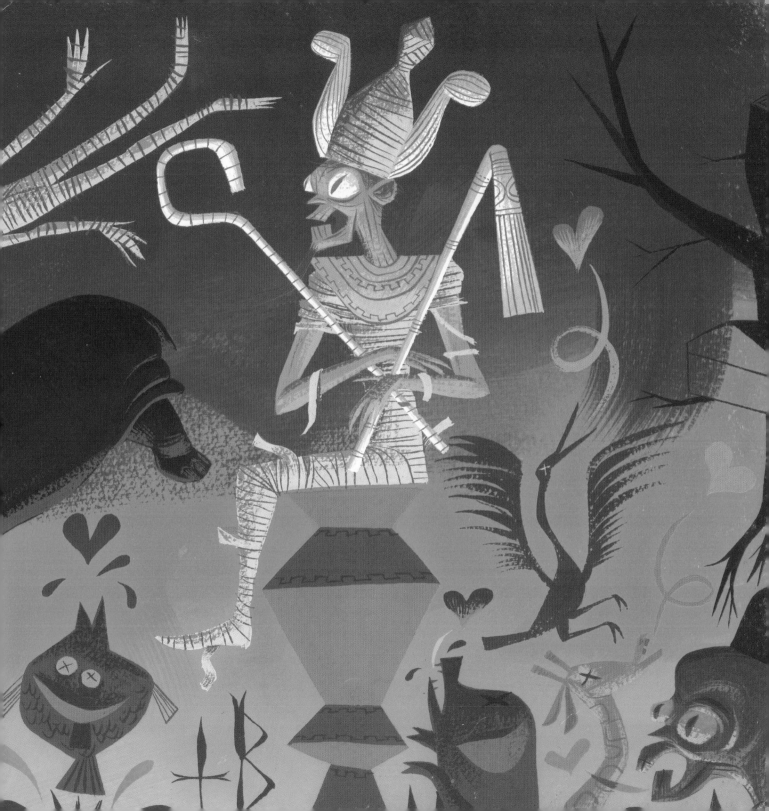

# Amermait

The voracious **AMERMAIT** of Egypt sits beneath the scales of justice in the underworld. Comprising aspects of three deadly beasts—the jaws of a crocodile, the head of a lion, and the body of a hippopotamus—the **AMERMAIT**, or Ammut, devours the souls of the unworthy with expert ferocity. When a soul arrives for judgment, its heart is weighed upon the scales against a feather that represents the truth. The heart must weigh the same as the feather—neither more nor less—for a soul to escape the appetites of the **AMERMAIT**.

Previous: Plate 05 . TIM BISKUP

# Acephalite

Meaning literally "those without heads" in Greek, the horrendous and largely anarchic **ACEPHALITES** have been sighted in many different locales in northern Africa. These headless humans, if one can call them humans, are said to have eerily penetrating eyes below their shoulders and wide mouths above their waists. Little is known of their behavior and tendencies, but their appearance alone is likely to inspire alarm and terror.

Opposite: Plate 06 . JASON ROBARDS

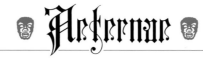

# Aeternae

For countless generations, the terrible race of giants known as **AETERNAE** has terrified those Europeans who have dared to stray from the civilized regions of their continent. The monster is a tremendously large humanoid creature with shaggy gray fur. A fierce, sawtoothed horn juts from its immense fore-head, and is used both for attacking and, eventually, dismembering prey. Though **AETERNAE** may prefer livestock, they are not averse to eating even large groups of people who come too near. Lying squarely between the great apes and humans in their level of intelligence, they are best dealt with using cunning, traps, and, best of all, avoidance.

Plate 07 . RYAN CLARK

# 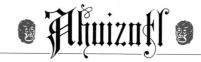 Ahuizotl

The doglike, vengeful AHUIZOTL hunts unsuspecting fishers who have allegedly stolen its fish. Distinguished by its monkey paws and the third hand at the end of its tail, this dark, aquatic creature of Aztec origin lures anglers by forcing small fish to the surface, creating the illusion of a lucrative fishing hole. Once the boat is situated to its liking, the AHUIZOTL uses its clever hand-tail to overturn the vessel and drag its human prey to a horrendous underwater death. Corpses of those attacked by the AHUIZOTL are easy to identify—the bloated victims float to the surface robbed of eyes, nails, and teeth.

Plate 08 . CHARLES GLAUBITZ

# Aitvaras

Also called the Damavykas or the Koklikas, this Eastern European entity brings luck and riches to any house where it resides—although often at the expense of nearby homes, from which it pilfers gold, corn, and other valuables. The **AITVARAS** arrives in many households by accident; in others, its arrival comes in exchange for a person's soul. In either case, removal of the **AITVARAS** is extremely difficult. Usually appearing near or within the home as a black cat (or sometimes as a white or black cockerel), the **AITVARAS** travels in the form of a fire-breathing dragon.

Plate 09 . ESTHER PEARL WATSON

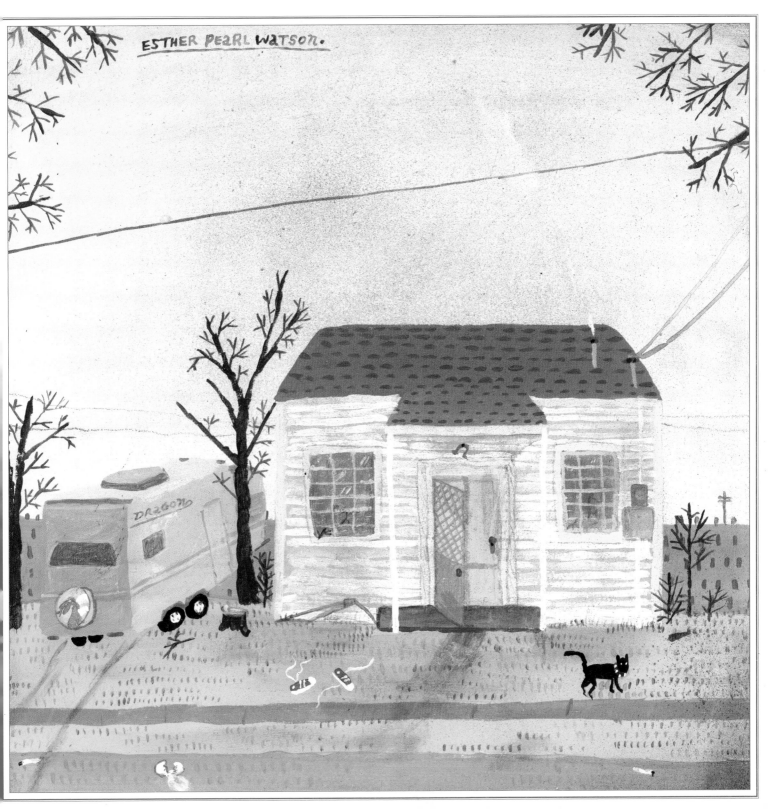

# Albastor

It is rumored in certain former Soviet republics that when a bastard child dies without having received the sacrament of baptism, its soul remains behind and gathers new flesh about it to form an **ALBASTOR**. Most frequently discovered lounging in rustic saunas in the form of an enormous man or woman with long, sweeping tresses, the monster may turn into a cometlike shower of sparks if disturbed and fly from place to place until settling down once again. The **ALBASTOR** enjoys kissing humans more than any other activity—but those who spend too much time in its ardent embrace develop recurrent sores on their faces that identify them as too lustful.

Plate 10 . RONALD KURNIAWAN

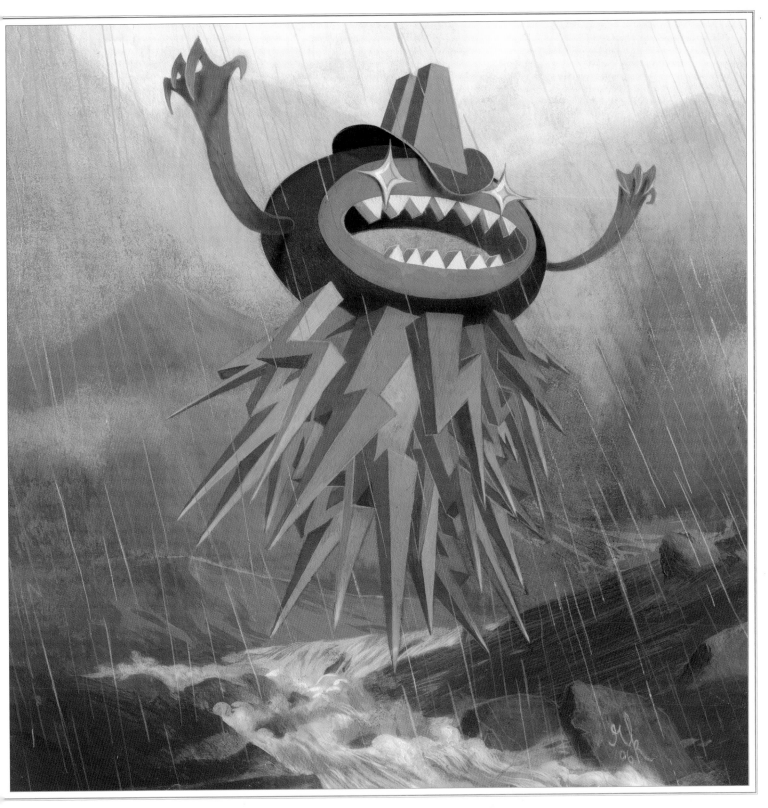

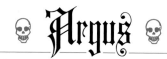

# Argus

Suffering a fitful existence, never fully awake nor wholly at rest, the benign **ARGUS** is a Greek giant of 100 eyes—50 of which remain asleep, 50 of which are always open and alert. The restless **ARGUS** is a superb watchman whose greatest vulnerability is the boredom that may lull him into complete unconsciousness, rendering him susceptible to the possibility of assassination.

Plate 11 . JACOB COVEY

# 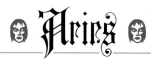 Aries

The origin and qualities of **ARIES**, also called Chrysomallos, are clouded by legend—in part because **ARIES'** fleece is better documented than the creature itself. Thought by early Greeks to be either the agent or the manifestation of a cloud spirit, this flying golden ram is known for its daring rescue of the spirit's twin children from ritual sacrifice. The sister twin fell into the sea shortly after the rescue. The brother, upon reaching safety, showed his thanks by sacrificing **ARIES** and hanging its fleece in an oak grove guarded by a sleepless dragon.

**Plate 12** . DETH P. SUN

# Asp Turtle

In Mediterranean waters spotted with islands, the **ASP TURTLE** (the Greek Aspidochelon) unintentionally beckons inattentive seafarers to dock upon its massive hide. Floating dormant as a crocodile, the breached back of the **ASP TURTLE** appears as a small flinty island growing the occasional trees and shrubs. Once disturbed by the landed sailors, the creature may banish the nuisance by simply sinking lower into the sea and dragging ship and crew to the ocean bottom. However, it is not always so passive. When particularly hungry or aggravated, the **ASP TURTLE** (likely the same ancient beast to have swallowed Jonah) will surge from the water in pursuit of men, its gaping maw booming.

Plate 13 . R. KIKUO JOHNSON

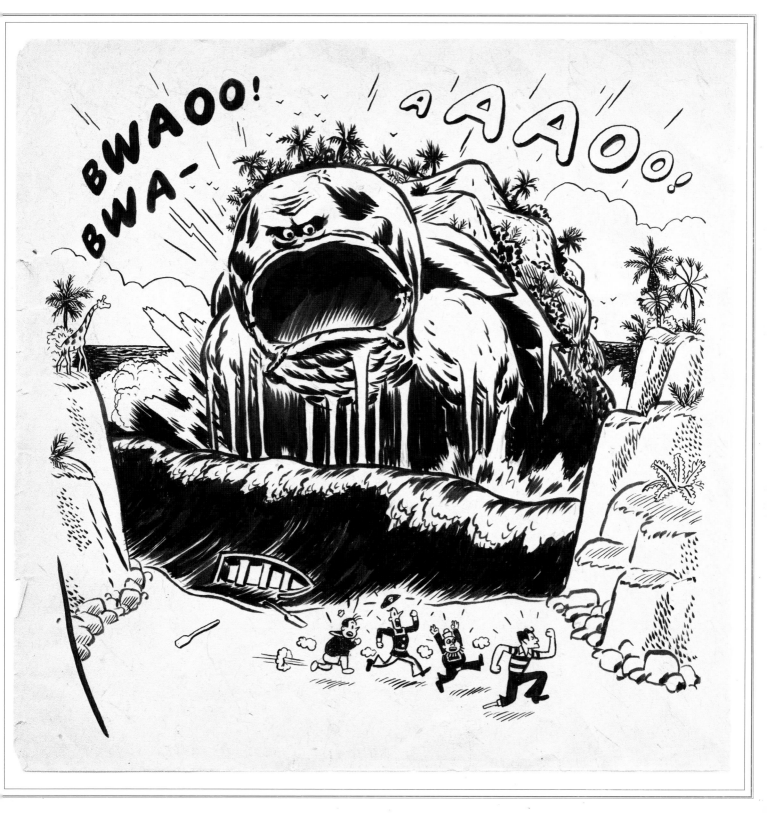

# Aspis

Smaller than a standard dragon but no less deadly, the European ASPIS can kill its prey instantly with even the slightest bite—and the only known cure for such a wound is immediate amputation of the affected limb. Likewise, anyone who touches the skin of an ASPIS, even a dead specimen, will succumb to the creature's virulent, tumor-producing poison. The ASPIS is easy to avoid, though, thanks to its well-documented weakness for music. Hearing even the simplest tune will charm an ASPIS to distraction. Aware of its own susceptibility, the ASPIS may attempt to hold one ear to the ground and plug the other with its tail—although this, too, renders the creature effectively harmless. Some cryptozootheologians speculate that, in this position, the ASPIS represents the wealthy and the worldly, with one ear blocked by sin and the other blocked by earthly longing.

Plate 14 . JULIE MURPHY

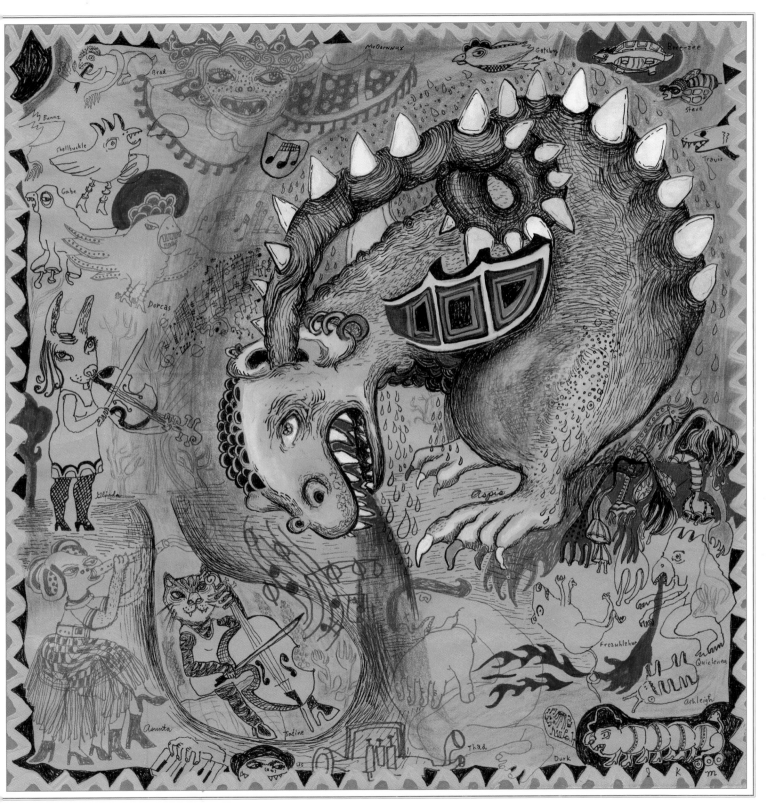

#  Aswang

Constantly bloodshot in the eyes from nocturnal pursuits, **ASWANG** takes the appearance of average Filipino townspeople during the day and travels by night with only the blackened form of its head and intestines supernaturally hovering. Partial to the sick and especially to pregnant women, the **ASWANG** consumes the intestines of vulnerable prey. Should its victim be awake, the creature will release a putrid, paralyzing gas before its long tongue and tweezing nails are used to devour the captive's insides. Sensing the unborn within exposed bellies of sleeping women, **ASWANG** are attributed to the stealing of babies before birth. Once finished, this ghoul leaves behind a cruel replica made of sticks, grass, and debris for the expectant mother to later discover. Despite its wicked evenings, the **ASWANG** has a shy personality in daylight hours and can be identified by the inverted reflection upon the surface of its eyes.

Plate 15 . MARTIN CENDREDA

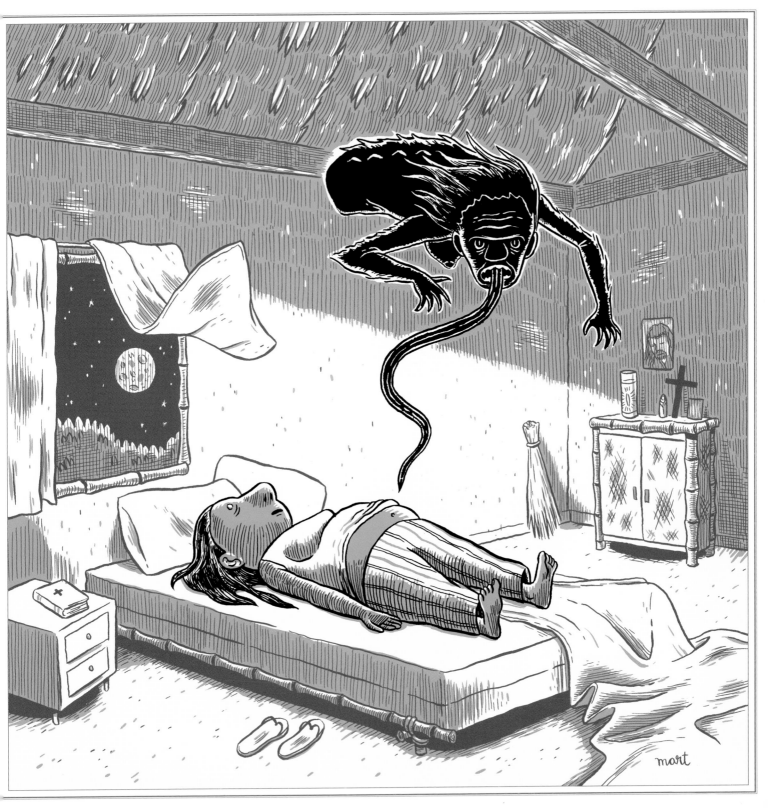

#  Auvekoejak

A furry merman can wreak great havoc on a successful fishing career, as Inuit peoples of Greenland and northern Canada have witnessed firsthand. One of these rare sea beasts, the **AUVEKOEJAK**, is humanlike except for its fins and tail, and is completely covered in fur. Though posing no direct danger to humans, the **AUVEKOEJAK** glides stealthily through the arctic waters chomping down whole schools of fish in its ravenous feeds. Visiting explorers have pointed out the similarities between these hirsute merfolk and sea cows or seals, but the Inuit have asserted that they are entirely different creatures.

Plate 16 . BRENT JOHNSON

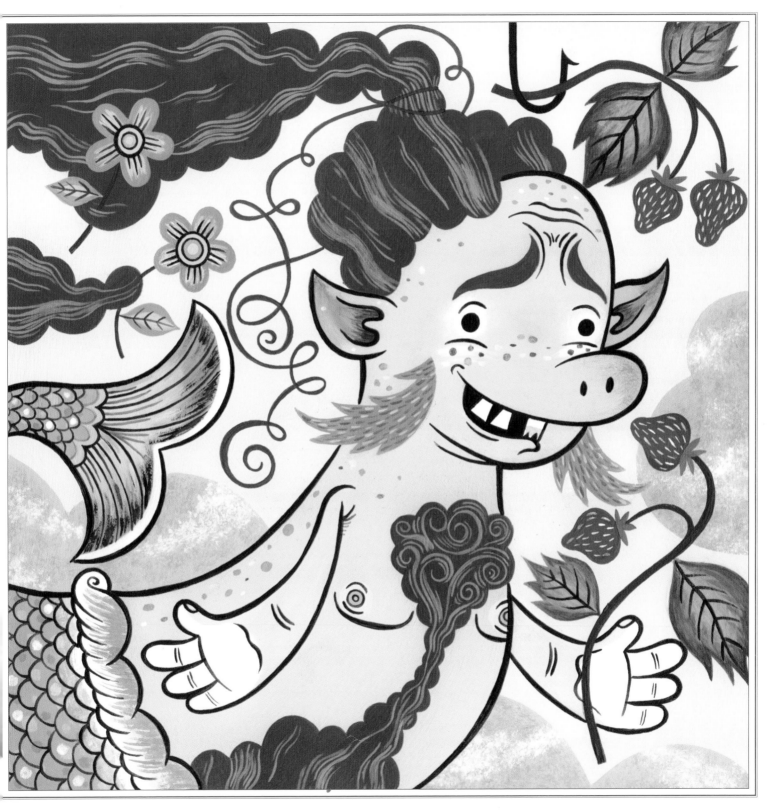

# 𝔅𝔞𝔟𝔞 𝔜𝔞𝔤𝔞

**BABA YAGA**, a hideous hag, gets one year older every time she is asked a question. Feared throughout northern Europe and the forested Slavic regions, this mercurial crone awaits querying visitors and passing children in her revolving, chicken-legged hut encircled by a bone fence inlaid with the glowing skulls of her victims. As people approach, she will respond in one of three ways: she will grumble at them for disturbing her, frighten them away with threats to cook them for dinner, or coax them into a lethal accident so she can swallow their souls.

Plate 17 . COLLEEN COOVER

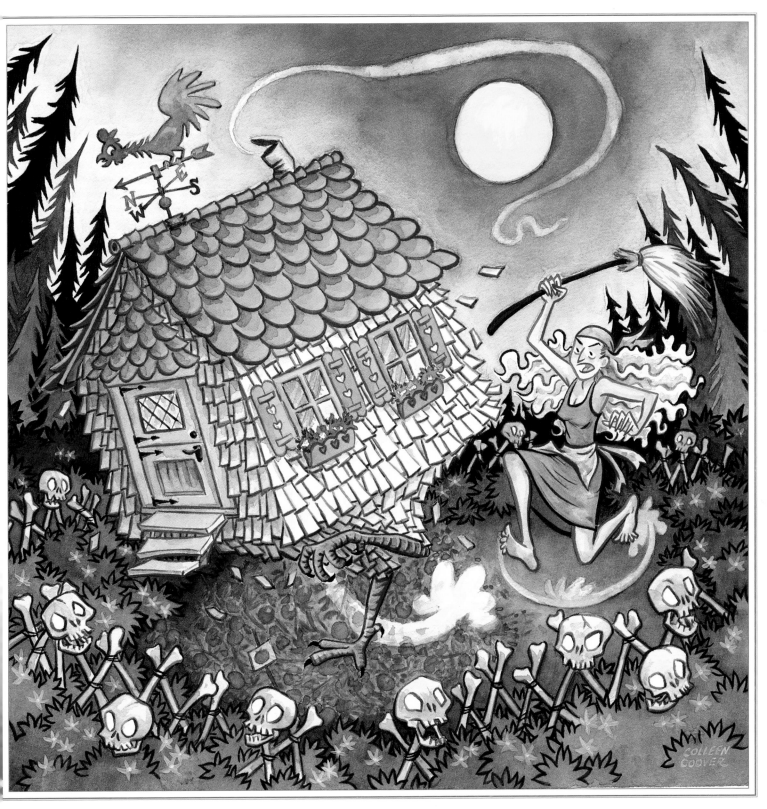

# Banshee

The **BANSHEE**'s piercing wail foretells a death in the family. Cloaked in a gray, hooded robe or wearing a burial shroud, this long-haired, weepy-eyed Irish fairy appears as either a young, middle-aged, or old haglike woman. Some have observed that these three **BANSHEE** figures reflect the triple aspects of the Celtic goddess of war and death. Occasionally the **BANSHEE** appears as a washerwoman, scrubbing bloodstains from the clothes of the person about to die. If a **BANSHEE** is caught, she must disclose the identity of the doomed one, the object of her portentous wailing.

Plate 18 . KATY HORAN

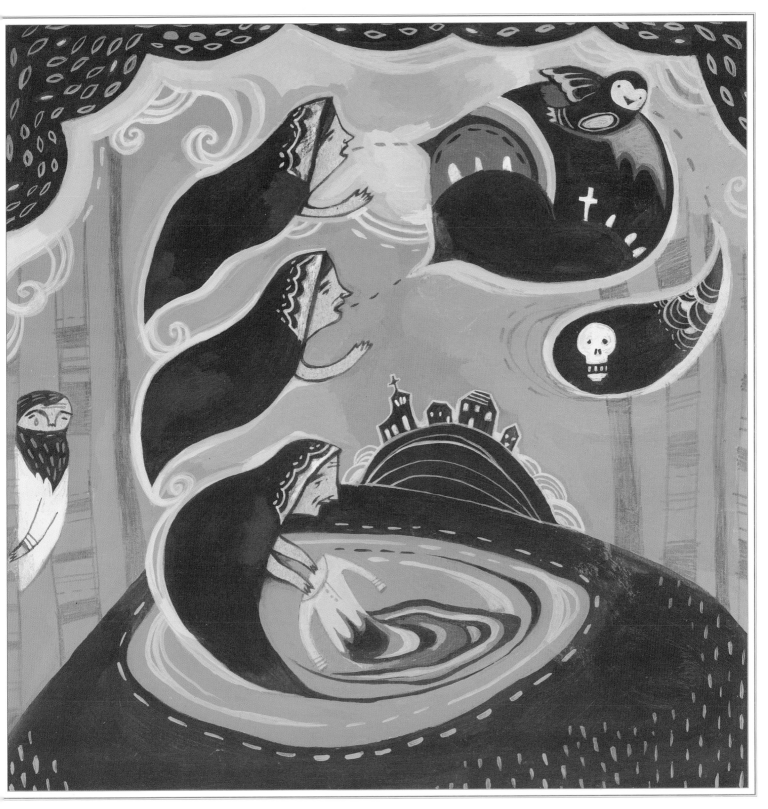

# Barguest

Known also as Barvest, Striker, Black Shuck, Moddey Dhoo, and Gwyllgi, Dog of Darkness, the devilish BARGUEST of England and Wales has adopted many forms. By some accounts, this calf-sized phantom dog leaps through the air, terrifying villagers with its sinister horns, stinging fangs, and fiery eyes and rousing the town's domestic dogs to an irrepressible fit of howling. In some stories, the beast resembles a white rabbit or a headless woman. In others, it drags chains, inflicts unhealing wounds, and disappears in flames. Through multifarious tales this demon maintains one consistent trait: its approach immediately precedes a death in the town.

Plate 19 . DEAN YEAGLE

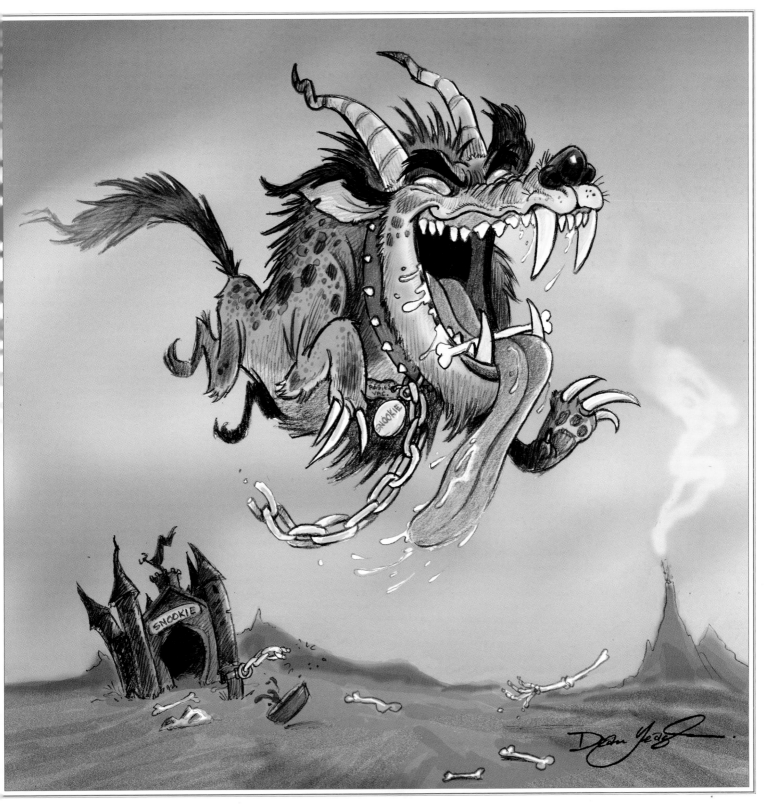

# Barometz

The malevolent and invasive **BAROMETZ** is a plant-animal hybrid both feared and desired. Native to central Asia, the **BAROMETZ**, also known as the Vegetable Lamb of Tartary, has snaky roots that suck the land dry of nourishment. Instead of flowering, the plant blossoms into vicious, omnivorous sheep. Tethered to their stalks, the sheep blossoms then strip the land around them until, ultimately, they starve themselves to death. Curiously, a dead **BAROMETZ** is prized for its succulent, crablike flesh, fine wool, and bones that, when crushed, impart the gift of prophecy. Those able to avoid their blossoms can uproot the plant or sever the stalk, thereby killing it. This is dangerous, though, and the screams of a dying **BAROMETZ** can be heard for miles.

Plate 20 . KAELA GRAHAM

# Bautatsch-Ah-Ilgs

Resembling a bulging, walking stomach, the BAUTATSCH-AH-ILGS lurks in the waters of Switzerland's Lake Lucerne, which has long been considered a portal to hell by the Swiss. Although the BAUTATSCH-AH-ILGS is rarely seen upon the shores and hills surrounding this otherwise idyllic and photogenic lake, eyewitness accounts agree on the misshapen beast's malevolent, fire-spouting eyes.

Plate 21 . JESSE LeDOUX

# Beast of Bray Road

Though often confused with the Michigan Dog Man and a variety of Wisconsin Bigfoot known as the Bluff Monster, the **BEAST OF BRAY ROAD** is quite possibly a form of modern American werewolf. (Setting aside, of course, the outright dismissal of shapeshifters by many serious cryptozoologists.) Whatever its physiology and extraction, most accounts agree on the beast's general phenotype: a muscle-bound man-wolf hybrid. The creature displays a shaggy grayish black coat, wide shoulders and chest, glowing yellow eyes, and canine ears and teeth. Some describe an accompanying odor of putrefied meat. Others attribute altruistic behavior and even telepathy to the creature. The beast can currently be found in a range that includes the Wisconsin towns of Elkhorn and Delvan, according to a cluster of accounts in the late 1980s and 1990s. One report in particular predates and in some ways differs from this more recent flurry of sightings. Most notably, the witness prudently refuses to speculate on any lycanthropic traits the creature might possess. This early account places the beast near Bray Road, along Wisconsin State Highway 11. Marvin Kirschnik, a Williams Bay businessman, came forward in 2003 with the following statement and a sketch of the creature:

*On September, in 1981, I was traveling down Highway 11 in Walworth County. Something caught my eye in a field, off to my right. It was a sunny afternoon around 3:30. In the field there was a broken tree and standing behind it was a figure. I pulled over and looked out from my van for a minute or two. The creature was six feet tall, dark-eyed, had a dog-like face and a human-like body. I stared at it; it stared at me. I became unnerved and finally drove away. The creature's gaze followed me as I left. I didn't know what it was. —MK*

· In April 2006, just days after an interview with the *History Channel* where he participated in a lie-detector screening, Mr. Kirschnik spoke with the Curator and related the same account as above. Not wishing to risk losing the illustration he had drawn shortly after the beast encounter, he drew this near-duplicate to appear in *BEASTS!*. The facial close-up on the opening page is also new and was generously created for this collection.

Plate 22 . MARVIN KIRSCHNIK

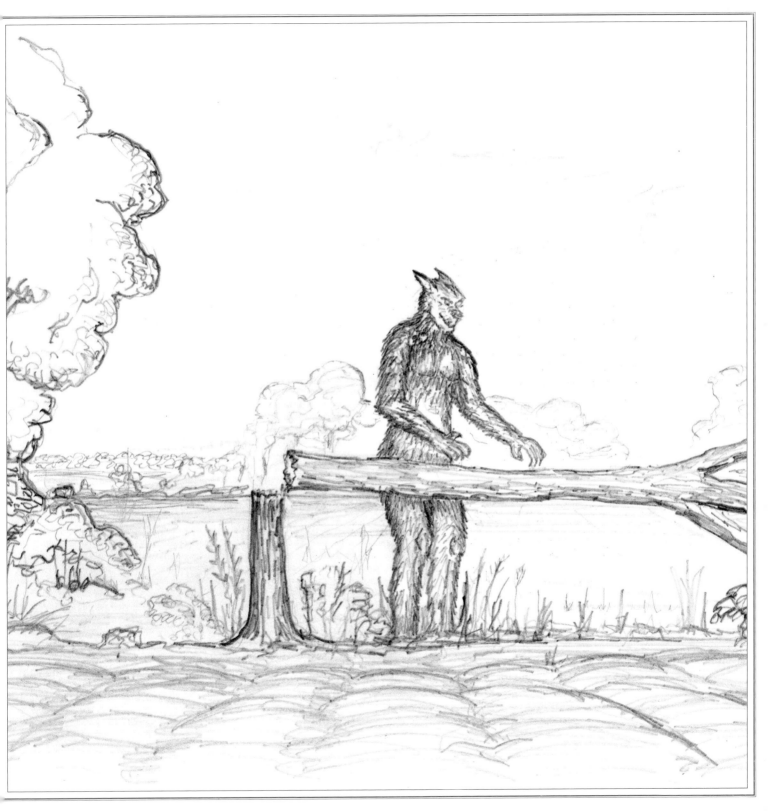

# 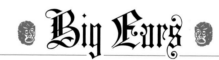 Big Ears

Named somewhat unimaginatively for its gigantic ears, **BIG EARS** is the mammoth yellow-eyed devil cat summoned in the Taghairm divination ritual. Conducted primarily in 17th-century Scotland, this ceremony involved roasting cats alive day and night. On the fourth day of continuous, painful caterwauling, **BIG EARS** appeared with its entourage of black-cat demons, loosed an otherworldly howl, and granted the terrified conjurers' requests for riches, knowledge, or second sight. A version of Taghairm is still performed, without the sacrificial cats.

Plate 23 . ANDREW BRANDOU

# 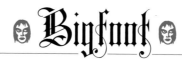Bigfoot

Also known as Sasquatch, Skunk-Ape, and Yowie, this enormous, reclusive, bipedal ape dwells in the temperate and colder regions of North America. Standing well over eight feet tall and covered with long, coarse hair, the adult **BIGFOOT** is certainly more fearsome in countenance than in behavior. Scattered reports of attacks notwithstanding, this elusive creature is far more likely to take flight from humans than to risk capture or worse. The **BIGFOOT** is generally believed to be related to the yeti of Asia, perhaps descended from ancestors who crossed the same land bridge that first brought humans to the Americas.

Plate 24 . RENEE FRENCH

# Black Annis

In a cave outside of the English town of Leicestershire, carved with her own terrible claws and littered with albescent bones, **BLACK ANNIS** survives on a cannibalistic diet of man, woman, and child. Invisibly perched in the arms of a great oak standing lone in the remains of a once-prolific forest choked by evil, she awaits her prey to flay, devour, and display as skins along her walls. The ever-alert crone retains the remnants of just one eye staring out from sickly blue skin with white teeth gleaming sharply in the dark. Children are veal to her cruel hunger, leaving parents of the area imploring them not to wander.

Plate 25 . LESLEY REPPETEAUX

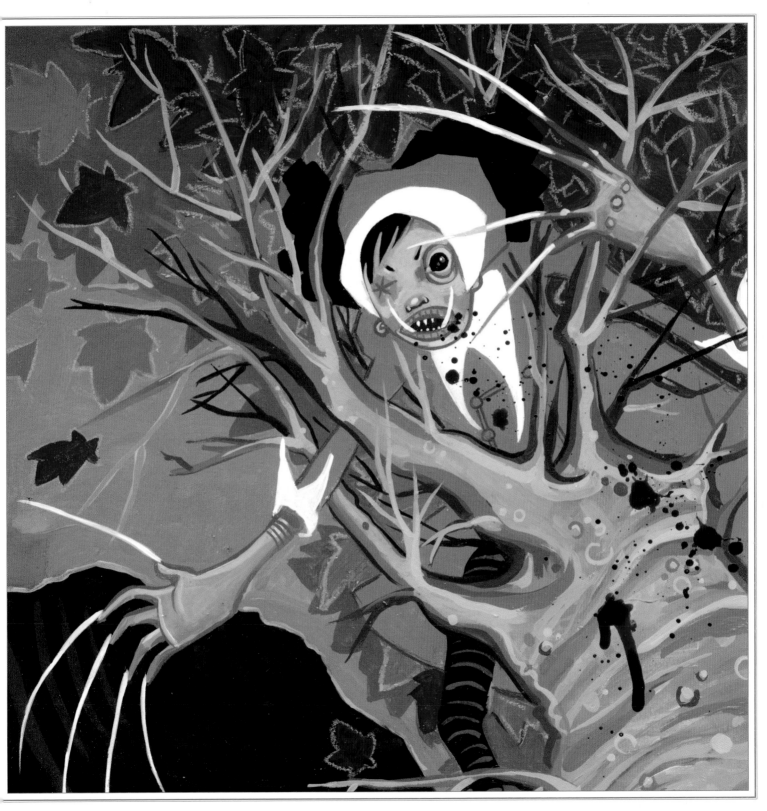

# 𝔅𝔬𝔞

Ordinary save for its size, wings, and ears, this enormous snake is known to pursue herds of cattle across the pasturelands of Italy. Although probably capable of swallowing its prey whole, the **BOA** prefers instead to suck milk from the animals' udders. Once attached to an individual cow or ox, the **BOA** will feed until the animal dries up or dies. Those readers who wish to review this gruesome process in more detail are urged to consult the writings of Pliny the Elder.

Plate 26 . ERIC REYNOLDS

# 𝔅𝔬𝔯𝔞𝔯𝔬

These cannibalistic forest spirits live in the upper Amazon and are called **BORARO** ("the white ones") by the Tukano Indians. **BORARO** are huge, hairy-chested demons with long legs and enormous phalli. Their pale skin makes them easily recognizable in the Amazon forest, but certainly even more distinctive are their forward-pointing ears and backward-pointing feet. If the spirit is seen with a stone hoe, travelers beware—the **BORARO** is on the hunt. If attacked, the best defense is to knock the **BORARO** over; since they have no knee joints, they are slow to stand upright, which gives their prey ample time to run.

Plate 27 . KENNETH LAVALLEE

# Brownies

Generosity is the raison d'être of these industrious beings, known best in Scotland and England for their minuscule stature and consistently brown wardrobe. **BROWNIES** adopt cottages and houses, which they clean at night while the resident family is sleeping. They do not ask for any payment. In fact, **BROWNIES** will be deeply offended by a gift presented as wages, especially a gift of new clothes to replace their work-worn outfits, and leave immediately. To show appreciation, the family need only leave a small chair by the fire and a modest snack. If the family forgets these simple courtesies, the neglected **BROWNIE** may turn mischievous.

Plate 28 . ADAM GRANO

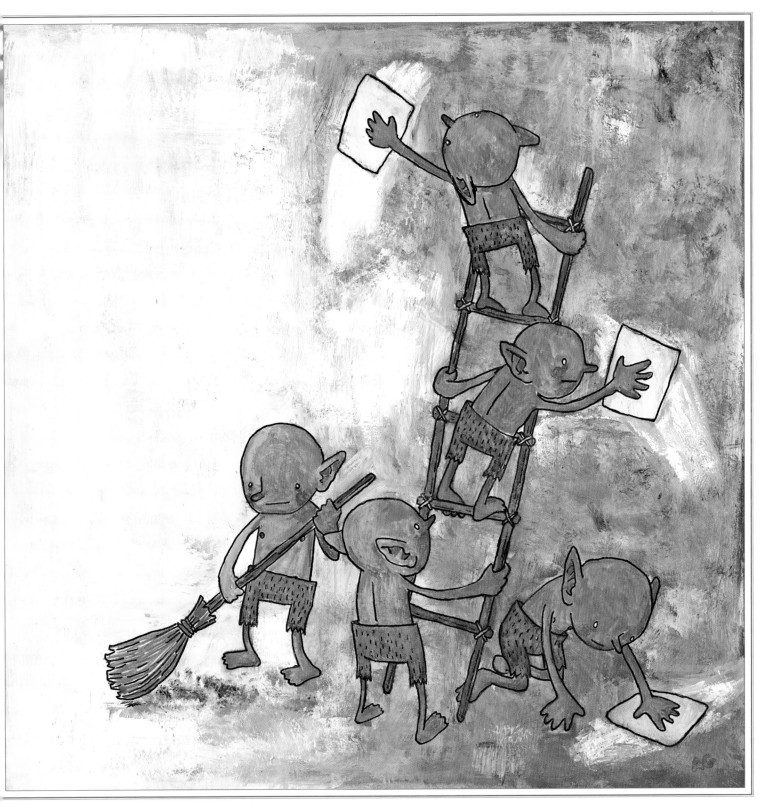

# Cacus

The word *cacus* can be translated as "wicked," and CACUS does its best to live up to the appellation. This huge spidery beast with three fire-breathing human heads lives in a cave in Italy's Aventine Hill, the home base from which it terrorizes townspeople. CACUS' appetite is voracious, and it is equally fond of human flesh and cattle. CACUS drags cattle by their tails back to its cave, giving the appearance that the beasts are moving in the opposite direction. It is far less subtle with its human victims, festooning the door of its cave with their severed heads.

Plate 29 . PJ FIDLER

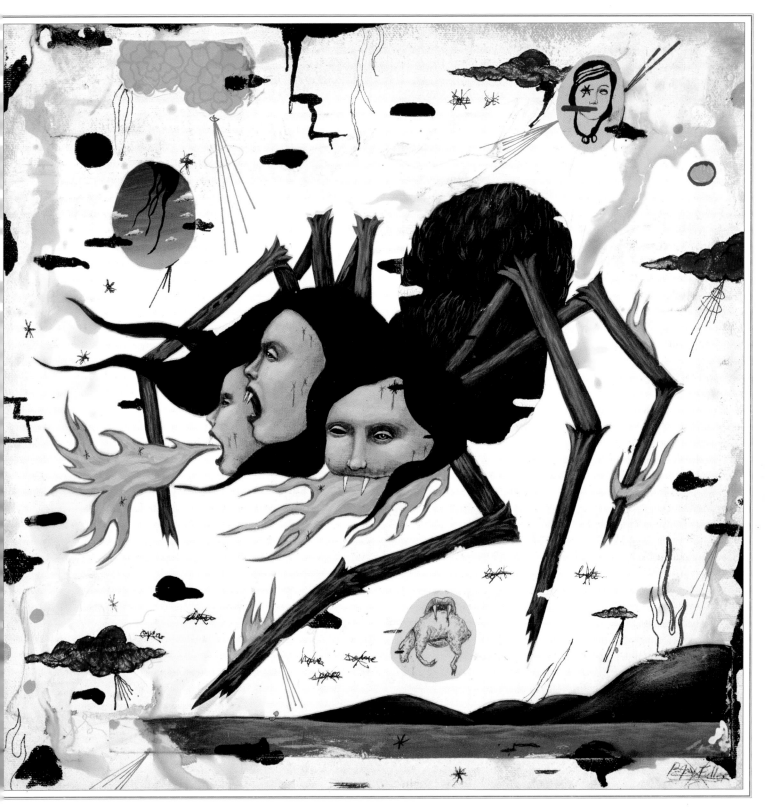

# 𝕮arn 𝕲alver

The late **CARN GALVER** lived in Cornwall, in a tiny English village near Penzance. His human neighbors never feared the ogre's gigantic size or grotesque features because he had a kind, simple nature. This loveable dolt was often observed playing with the children of his village, which he seemed to enjoy immensely. That is, until the day he inadvertently crushed a small boy—throwing him a boulder instead of a ball—and cried for seven years, pining for the dead child until he perished. A granite outcrop near the site of his death shares his name.

Plate 30 . BRIAN RALPH

# Catoblepas

The hulking **CATOBLEPAS**' thin neck meekly supports its massive head, which droops so severely that its apparent cowering belies the potentially lethal decision to approach this torpid beast. (In fact, *catoblepas* is Greek for "that which looks downward.") This wild, buffalo-like creature of Ethiopia feeds from a variety of poisonous plants, and a long mane masks its perpetually bloodshot eyes. Anyone who ventures near the **CATOBLEPAS** faces a grim demise: if its toxic breath doesn't kill, one look into its eyes will turn a person to stone.

Plate 31 . ANGELA KONGELBAK

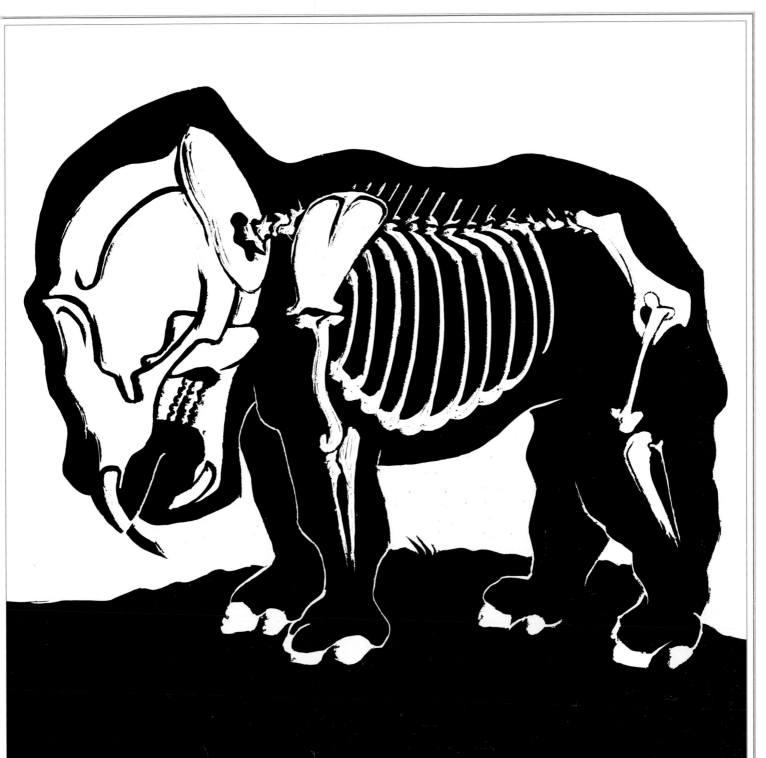

# Centaur

Wine, women, and war are all favorites of the passionate CENTAUR. This handsome Greek hybrid has the head, arms, and torso of a man atop a muscular horse's body, and his conflicted character mirrors this strange anatomical mix. If his physical make-up symbolizes the struggle between the civilized and barbaric, barbaric usually wins. Argumentative and rabble-rousing CENTAURS have been known to ruin banquets by tossing over tables, belligerently fighting, and foisting themselves upon women. Although arrogant and perhaps excessively appreciative of Dionysian delights, the intelligent CENTAUR can also be kind and considerate when need be.

Plate 32 . KEITH ANDREW SHORE

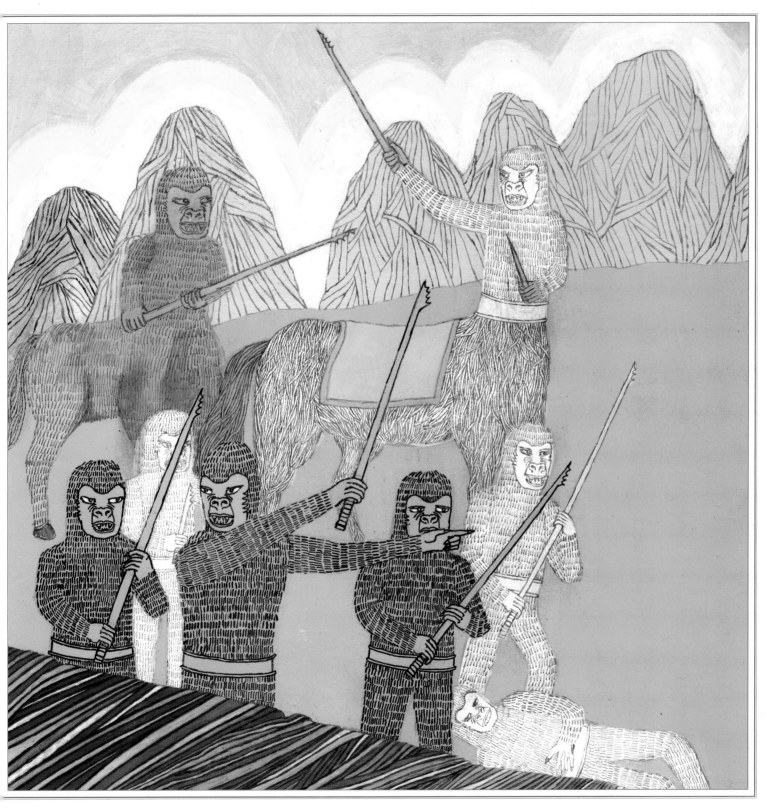

#  Cerberus

CERBERUS is the famed dog-beast that guards the single portal—entrance and exit—to Hades, home of the dead. The monster, first described by the Greeks, is aided in its guard-dog tasks by the serpents covering its three heads and the additional dragon heads lining its neck and back, all of which effectively terrify any live mortal hoping to enter. Hopeful escapees are merely torn apart. Though steadfast in its duties, CERBERUS can be soothed by music (particularly when played on a lyre) or drugged by honey cake.

Plate 33 . AMANDA VISELL

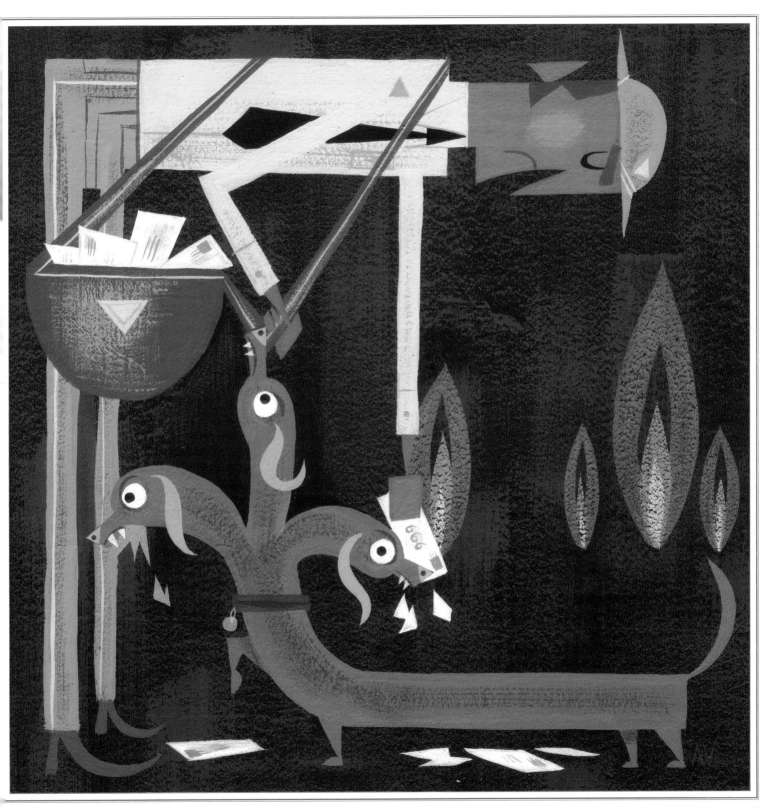

#  Cheeroonear

Aborigines recount the history of these part-human, part-canine monsters known to hunt the Nullarbor Plain of Australia. **CHEEROONEAR** live hidden in the forest, straying only to carry out vicious raiding trips on Aboriginal camps, stealthily leaving no evidence of their rampages but footprints. **CHEEROONEAR** arms are as long as their whole bodies, their head and ears are canine, and their bellies are often distended from gorging on water and human flesh. They enjoy eating infants whole, then vomiting up their undigested bones.

Plate 34 . MIKE HOFFMAN

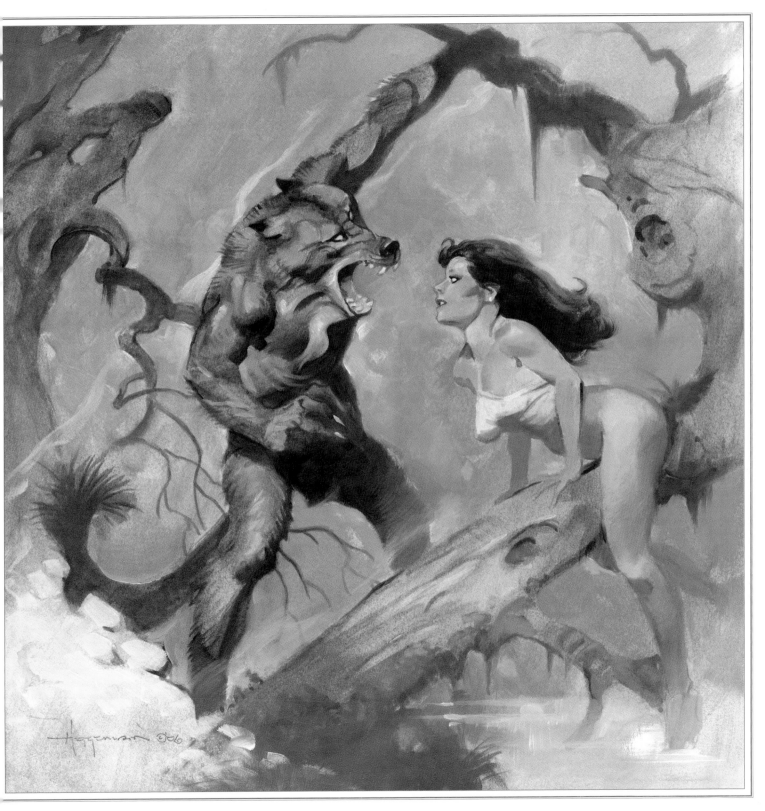

# Chenoo

The colossal CHENOO, an icy-hearted cannibal known to madly chew off even his own lips, is mentioned often in Passamaquoddy and Micmac stories by Native Americans in the northeastern United States. The CHENOO grows as tall as a tree and in fact uses uprooted trees as weapons, growing so crazed in battle that he will indiscriminately pound anything that moves. Some say the CHENOO was once human, a man driven insane by the isolation and bitter hardship of the desolate, frozen North, or perhaps an unusually good child whose heart was chilled and so became cruel and altogether wicked. This terrible man-demon will often seek out a shaman toward the end of his life and repent so he can return to mankind.

Plate 35 . MAT BRINKMAN

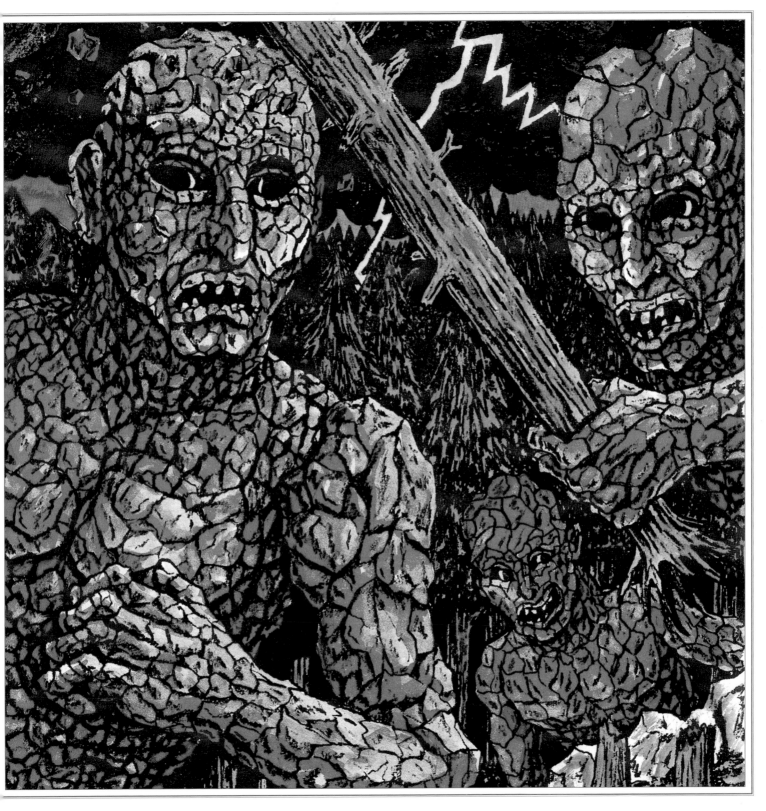

# Cliff Ogre

The **CLIFF OGRE** inhabits the high mountainous regions of North America and Europe and is noted, if not admired, among alpinists for its nurturing behavior toward its young. The **CLIFF OGRE** patrols its immediate environs for stray travelers, then drives its panicked victims over a cliff, either by tossing boulders at them, kicking them off, or simply hurling them to their deaths… straight into the clutches of its offspring below. The eager giantlets then devour the bodies hungrily. It does not take long for them to reach adulthood and perpetuate this barbaric cycle of life.

Plate 36 . SCOTT CAMPBELL

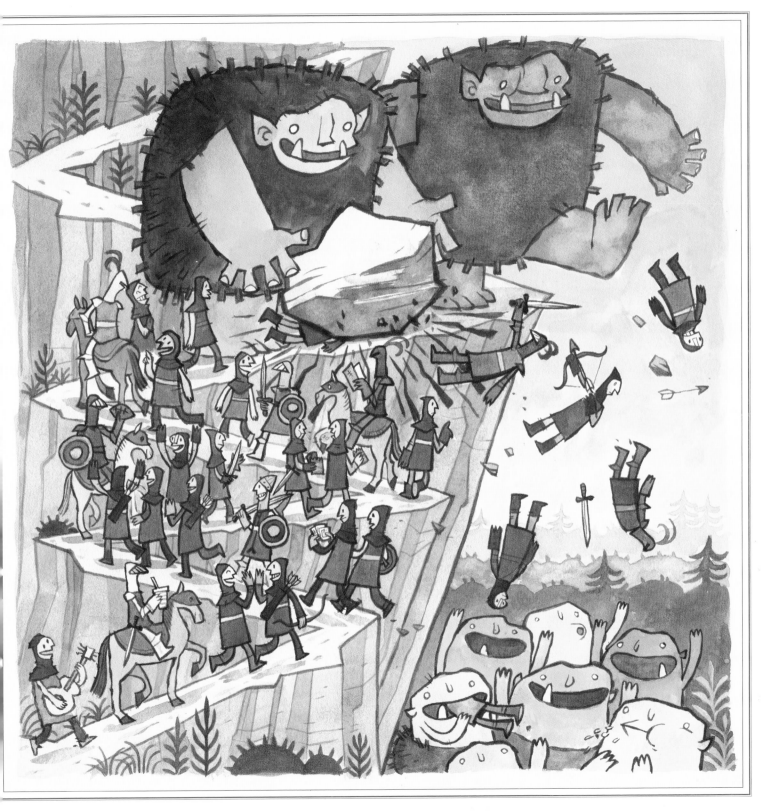

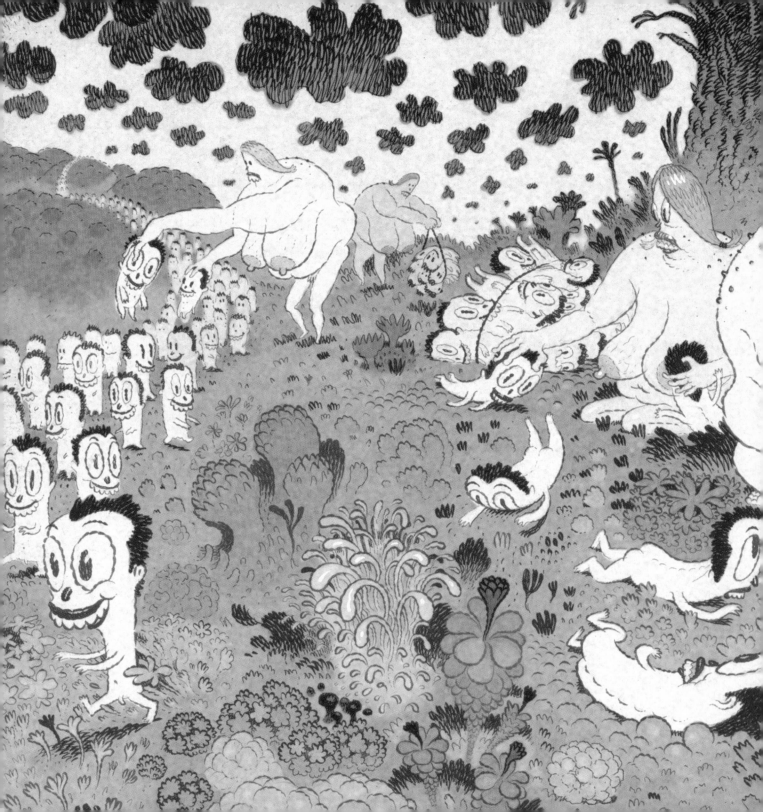

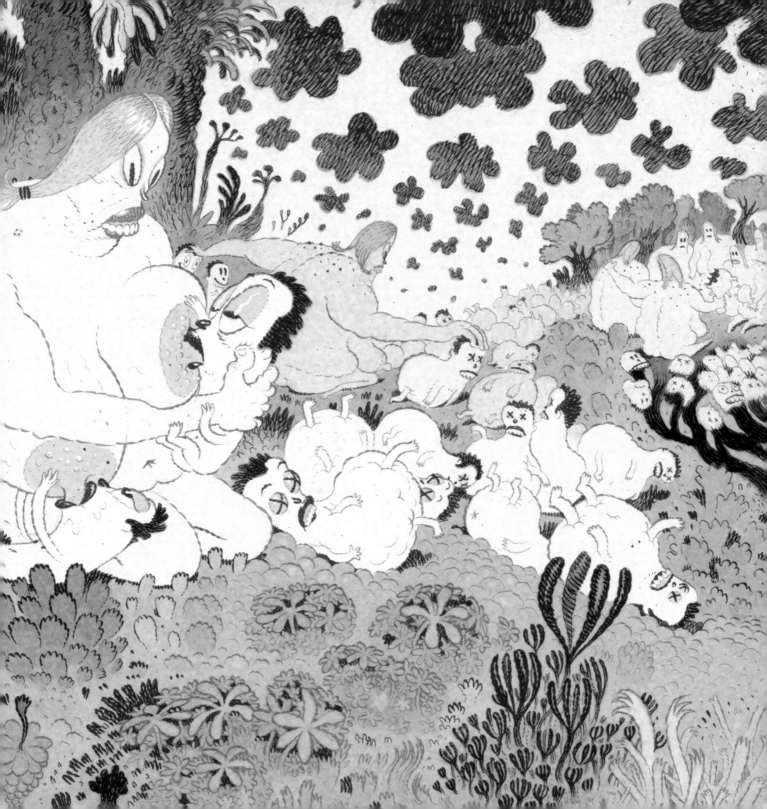

# Bapets

Malefic females of the giant Siat race, **BAPETS** were last recorded in the North American deserts of southwestern Utah and southeastern Nevada, where they proved particularly troublesome to procreating Ute tribe members hoping to increase their numbers. Said to prey on humans (particularly small children), the voluptuous **BAPETS** lure toddlers to suckle, then poison them with their lethal milk. Though generally considered immortal, **BAPETS** can be killed by arrowheads made from volcanic glass.

Previous: Plate 37 . DAVE COOPER

# Cyclopedes

These long-haired humanoids make good use of their limited appendages. On the single leg that protrudes from their torsos, **CYCLOPEDES** hop around with surprising agility. Residing primarily in treeless tropical regions of Africa and the Caribbean, they rest in the shade provided by their vast foot, often whiling away a whole afternoon. **CYCLOPEDES** also have one arm sprouting from their chests, which they sometimes partner with the leg to help them run. Related sciapod ("shadow foot") creatures were first noted by Pliny the Elder and later appeared in medieval bestiaries throughout Europe. They are generally recorded as startling, but otherwise non-threatening.

Opposite: Plate 38 . COREY LUNN

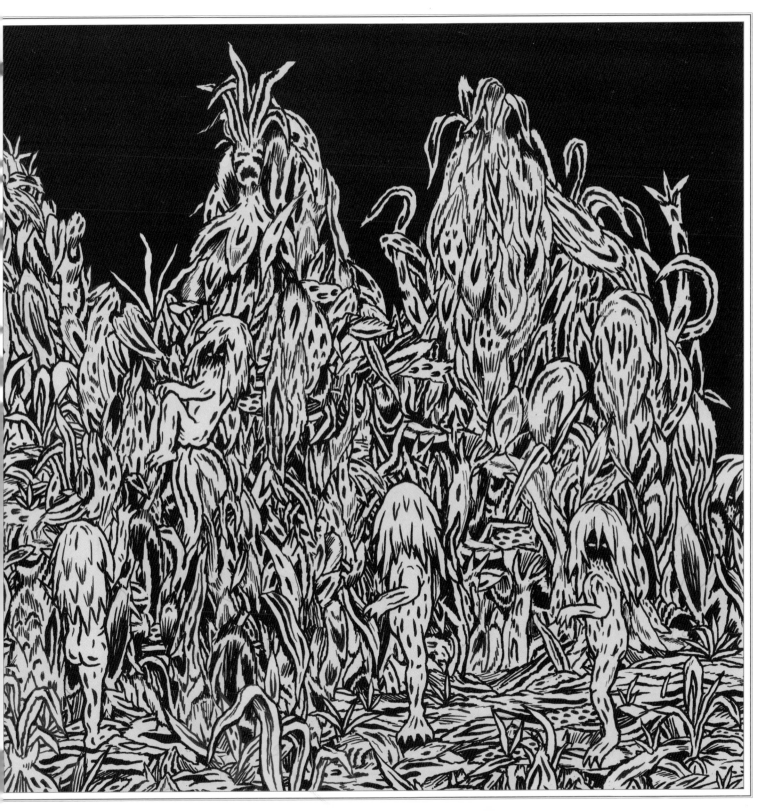

# Cyclops

Brother to the Greek Hundred-Handed Giants, the one-eyed CYCLOPS is as skilled at making weapons as it is in wielding them. This combative behemoth is notorious for its strength and nasty disposition. It is surmised that the CYCLOPS lost one eye due to a blacksmithing accident, and this event could account for its perennially hot temper. The CYCLOPS has not been reported in recent centuries, but remains a popular icon of misunderstood reclusiveness as well as aggressive myopia.

Plate 39 . NATE WILLIAMS

# Disemboweller

Known in Greenland as the **DISEMBOWELLER**, this eerie female is said to have been banished to Earth by her celestial family who had grown weary of her cruel practical jokes. Lonely and shunned, this so-called "cousin of the moon" relentlessly stalks people at night or hides outside their homes whispering nonsensical jokes and stories. Even the most serious human is unable to stifle a guffaw when the sadistic **DISEMBOWELLER** spins her ridiculous tales. Victims, crippled by mirth, laugh until they explode—their guts spilling distastefully onto the floor.

Plate 40 . ALEX MEYER

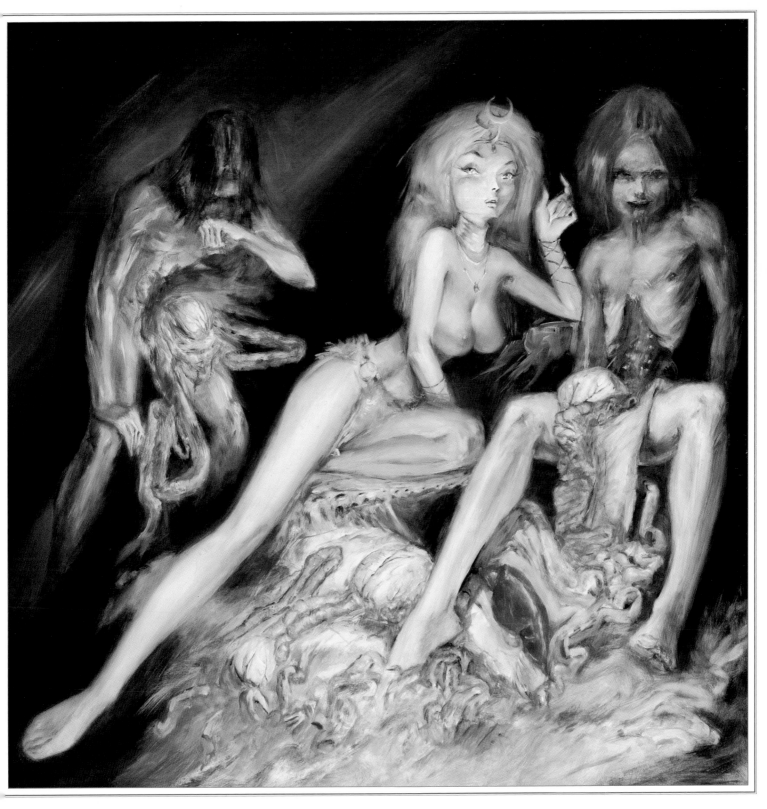

# Dog-Faced Bunyip

The **DOG-FACED BUNYIP** of Australia resides exclusively in creeks, billabongs, and other landlocked waters. This fiercely territorial and downright spiteful omnivore will go to great lengths to pursue trespassers, causing its native waters to rise above embankments, spilling over hills and even into homes. Some sources report that humans touching these waters are then transformed into black swans. Only women—for whom the **BUNYIP** displays a preternatural affinity—have been known to escape its appetites. Rather than devouring women, the **BUNYIP** carries them beneath the waters, holding them there, ensorcelled.

Plate 41 . DON CLARK

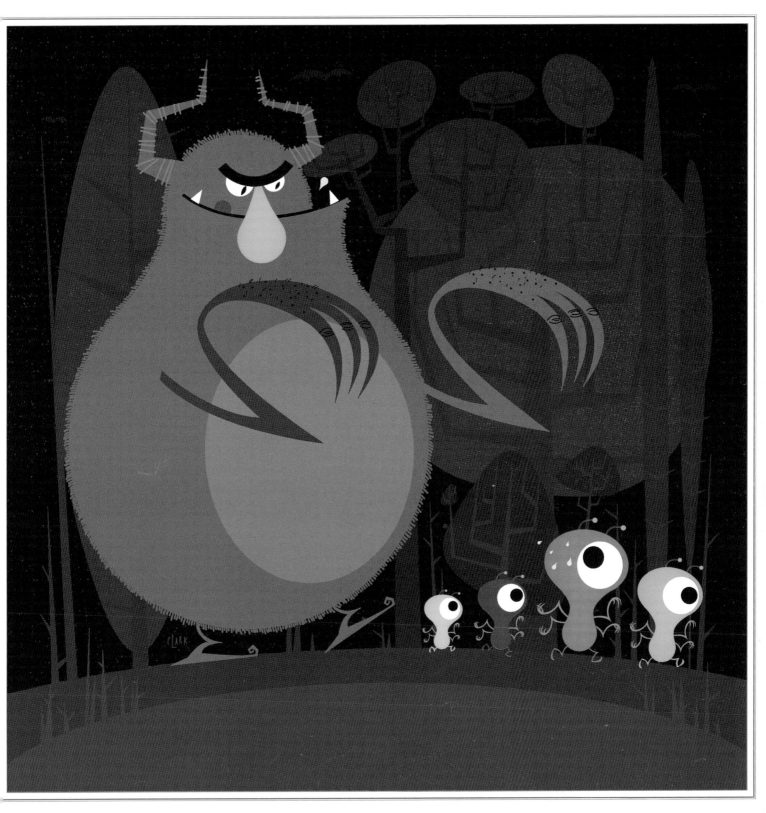

# Donestre

The **DONESTRE**, a humanoid monster with the head of a lion, is as well known in Europe for its twisted psychology as for its murderous nature. Possessed with the knowledge of every language, the charming lion-man lures travelers from around the world with kind words and intimate conversation. Having succeeded in segregating its prey from the group, the **DONESTRE** then kills and devours the traveler, leaving only the head behind. A witness to the **DONESTRE**'s dark and complex nature, the head remains uneaten—it is held, wept over, and desperately mourned by the guilty, self-loathing monster.

Plate 42 . KEVIN CORNELL

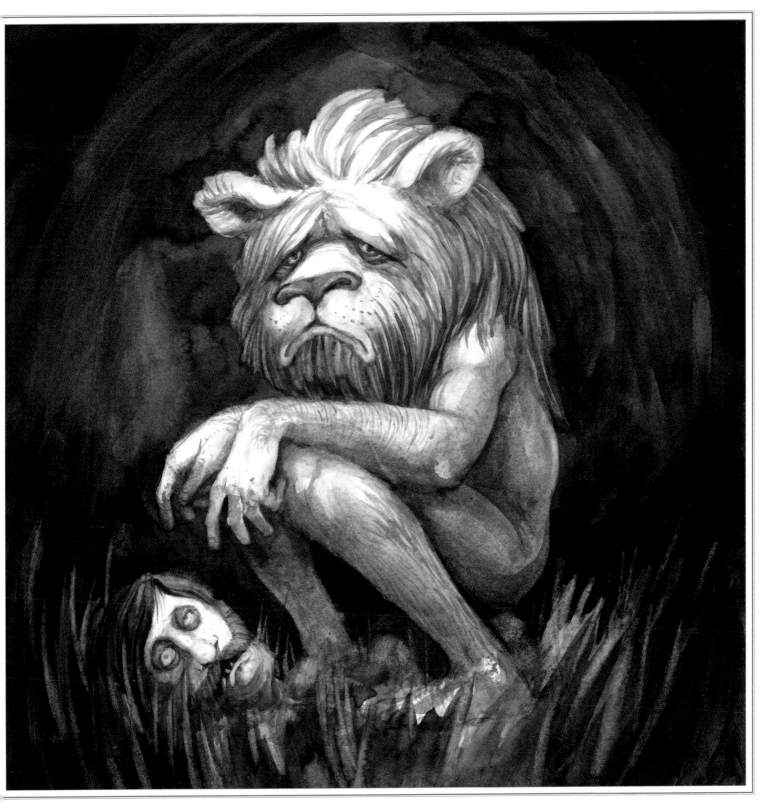

# Drac

The townsfolk of Beaucaire, France, live in terror of the DRAC and to this day honor it with an annual June procession. Although invisible to humans, the shapeshifting DRAC is generally known as a loathsome sea serpent that lures seafarers on passing boats with shiny baubles, only to drag them to their mortal fate. Villagers say that in 1250, the DRAC abducted a lavender seller and kept her in its watery lair for seven years to help raise its son. When the DRAC released her, she found she had "dragon sight." The DRAC ripped her dragon-sighted eye out and then went on to kill more than 3,000 townspeople and knights. Some say the DRAC died of old age; some claim it still lives at the bottom of the Rhône.

Plate 43 . NATHAN JUREVICIUS

# Draug

The Nordic **DRAUG** haunts the seas surrounding northern Europe, and it is said (by those few who have survived to observe it) that the lone watery spirit traverses those waters in but half a boat. Appearing as a drowned man with a seaweedy head, this zombie-like creature, perhaps denied a proper burial in life, warns sailors of their imminent doom. Ill fortune may come in the form of death, piracy, foundering, or simple sea-madness, but it will surely come. Some varieties of **DRAUG** are said to assume the forms of seaside stones, but little is known about them.

Plate 44 . RON REGÉ, JR.

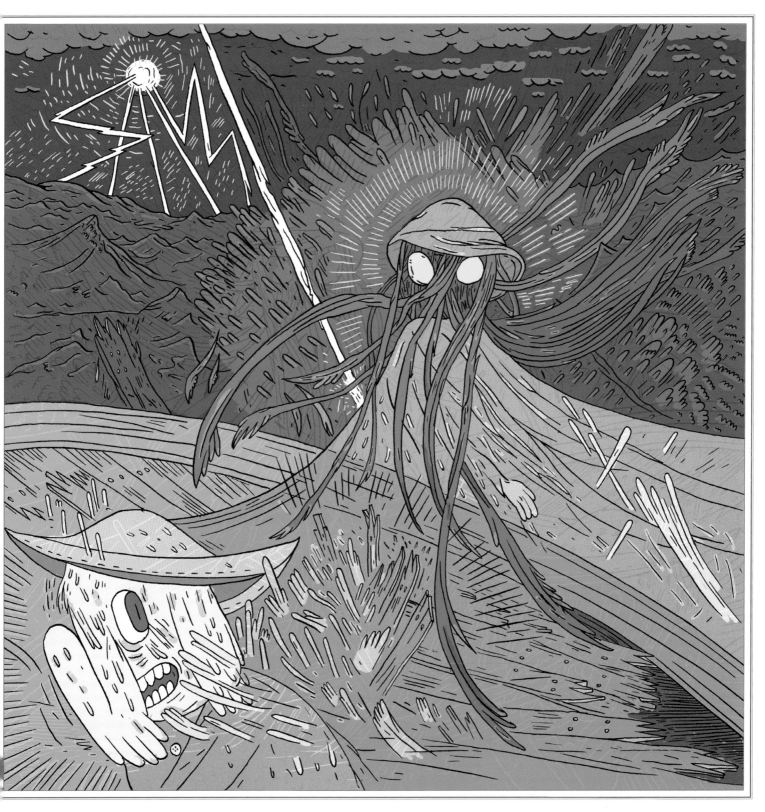

# Erinyes

The three Greek **ERINYES** are shockingly grotesque avengers also known to the Romans as the Furies (from the Latin word *furor*). With serpents writhing and coiling about their heads, wings beating at their backs, and blood weeping from their eyes, these fierce women mete out punishment to those who break natural laws, their specialty being familial killings. Their relentless justice-seeking takes the form of protection as well as persecution, and they will defend beggars, strays, and the generally defenseless.

Plate 45 . MEG HUNT

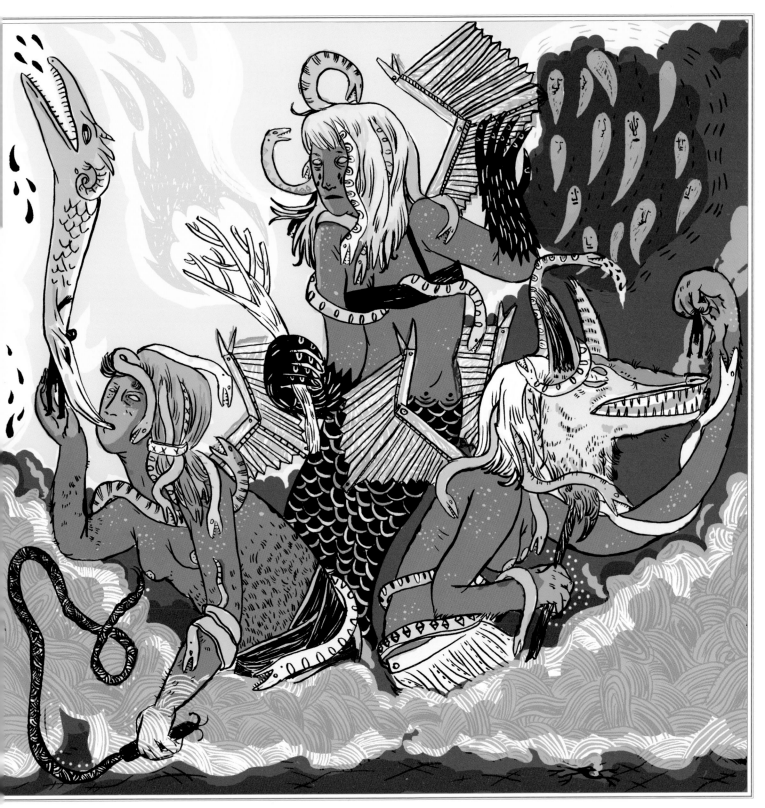

# Gaki

GAKI means "hungry ghost" in Japanese, and this monster is well named. These voracious, eternally tormented, humanlike beasts inhabit the islands of Japan and are unable to slake their hunger and thirst. This wouldn't pose a serious problem for the Japanese, were it not for the GAKI's filthy, razor-sharp claws, with which they can tear up even a hearty youth in mere moments. More than thirty-six varieties of GAKI have been reported. Some appear as large, brightly colored men bearing the heads of animals (horse and bull are most commonly seen) and three fully functioning eyes. Some theoreticians postulate that they are an extremely unusual variety of vampire, but more information is required before any firm conclusions may be drawn.

Plate 46 . STAN SAKAI

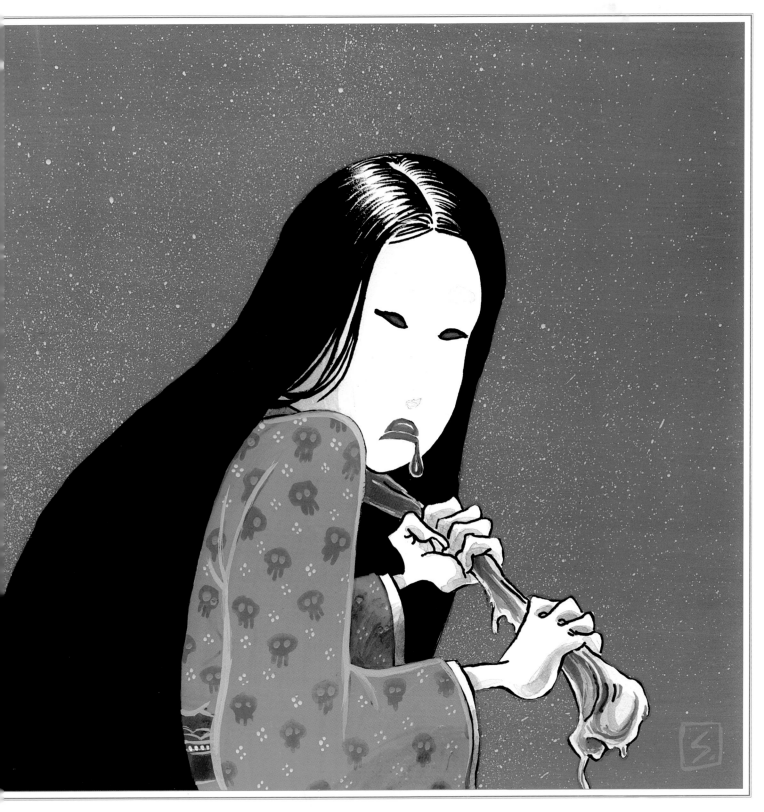

#  Golem

The **GOLEM** is a voiceless automaton brought to life by a rabbi. Formed of clay and animated with a special tablet placed under its tongue, it becomes a mindless drone charged with mundane tasks such as ringing synagogue bells and moving furniture. The creator's connection to God is said to give him the power to dominate this clay creature. Dangerous in their naiveté and ignorance, these sleepless minions have the reputed problem of creating mindless wreckage when unmonitored. To suspend activity of an animated **GOLEM**, one must remove the sublingual tablet.

Plate 47 . MARC BELL

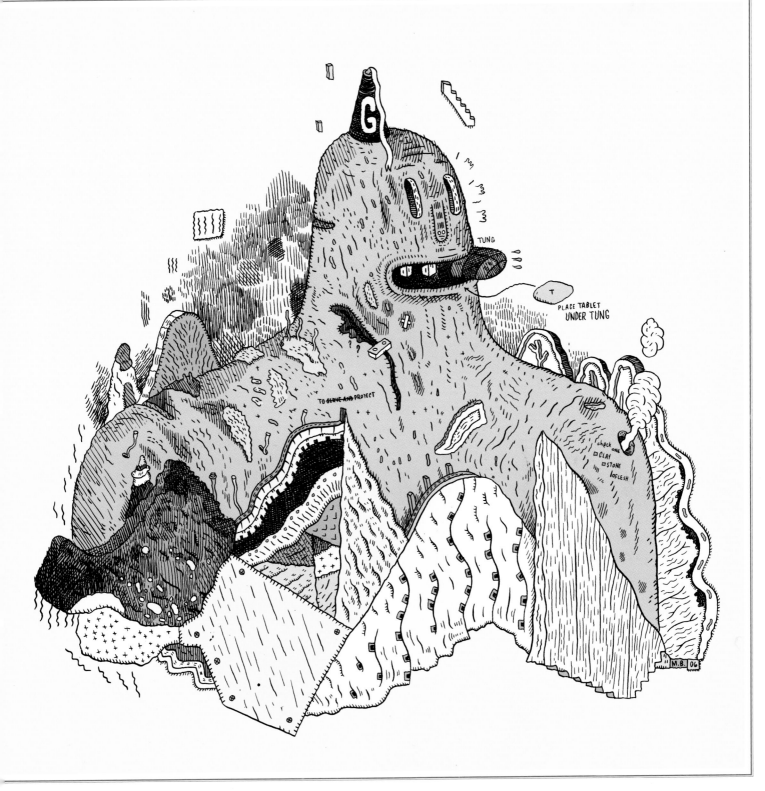

#  Gorgon

GORGONS are hag-beasts of Greek origin. Their resemblance to a human female deviates only in their hissing viper hair, reptilian torsos, and hideous smiles agape with dripping fangs and hanging tongues. An exact description of their eyes has not been recorded, as anyone who meets their gaze directly is petrified on the spot. Medusa, considered queen of the GORGONS, was said to be so terrifying that even her lifeless, severed head could turn warriors to stone. GORGON heads have often been depicted in shields or on doors to ward off intrusion or attack.

Plate 48 . DAN GRZECA

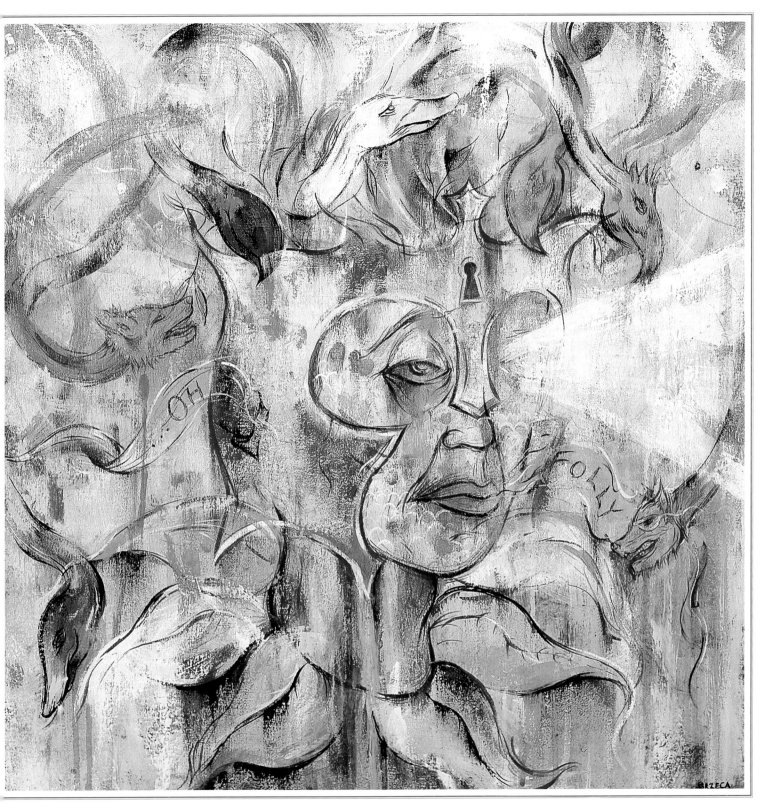

# Harpy

Opinions on appearance can vary wildly, even among trained observers. There is no better example of this phenomenon than the **HARPY**, considered graceful and lovely by some, utterly repugnant by others. In either case, these vile-smelling bird-woman hybrids of Greek origin have been known to make enemies. Whether stealing food or carrying off the unwilling to unending torment, the **HARPY** inspires sober caution and an often sudden desire to flee in any who spot it.

Plate 49 . JOHNNY RYAN

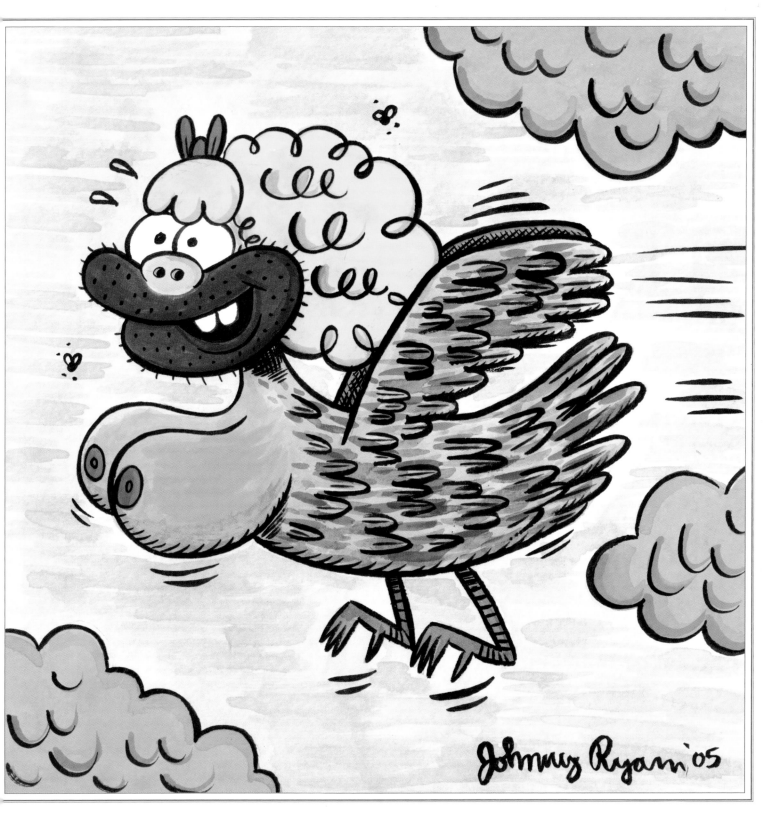

Johnny Ryan '05

# Hundred-Handed Giant

Life bears many challenges for a **HUNDRED-HANDED GIANT** with fifty heads. When this beast's father first saw him, he cruelly tossed him into a dank pit. Fortunately, he and his brothers, the Greek-born Hecatonchires, were rescued, and the same attributes that caused them to be initially shunned (physical ugliness and fearsome strength) made them invaluable allies in times of war. With a hundred hands, each capable of hurling mountain-sized boulders at great speed, these powerhouses almost guarantee victory for those with whom they ally.

Plate 50 . LITTLE FRIENDS of PRINTMAKING

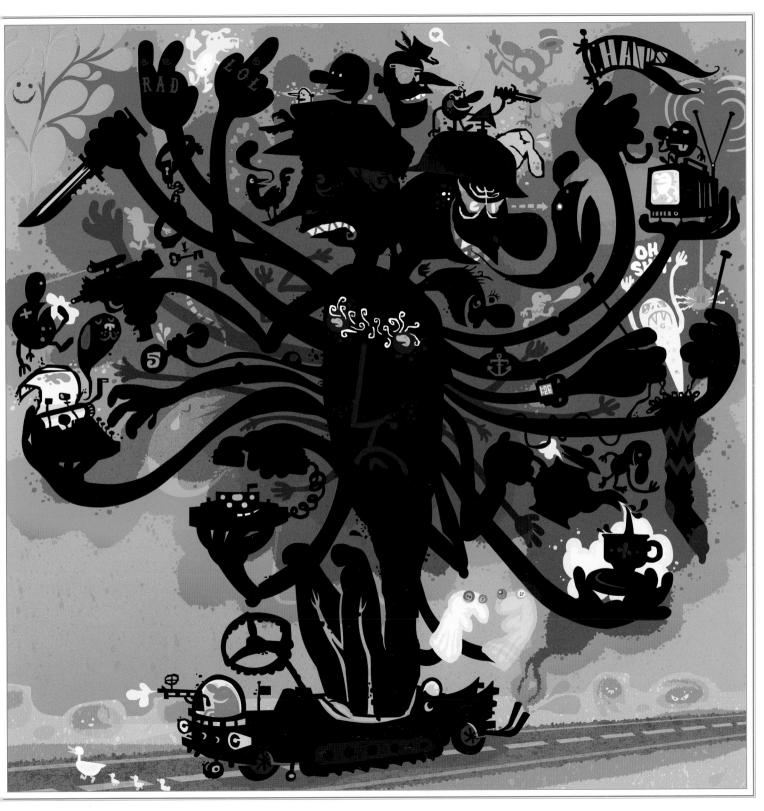

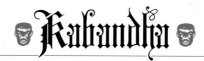

# Kabandha

Rakshasas are evil spirits in India that enjoy haunting and harassing humans. They can be revolting or beautiful, humanoid or monstrous. **KABANDHA**, whose name means "barrel," is one of the monstrous—a hairy, headless beast with eight arms, one eye, and a mouth full of fangs protruding from its swollen belly. Originally, **KABANDHA** was a Gandharva, a supernatural air-dweller, but then **KABANDHA** battled mightily with the king Indra. The dramatic and violent injuries sustained in this struggle drove **KABANDHA**'s arms and head into its torso, resulting in its fateful transformation.

Plate 51 . KEVIN SCALZO

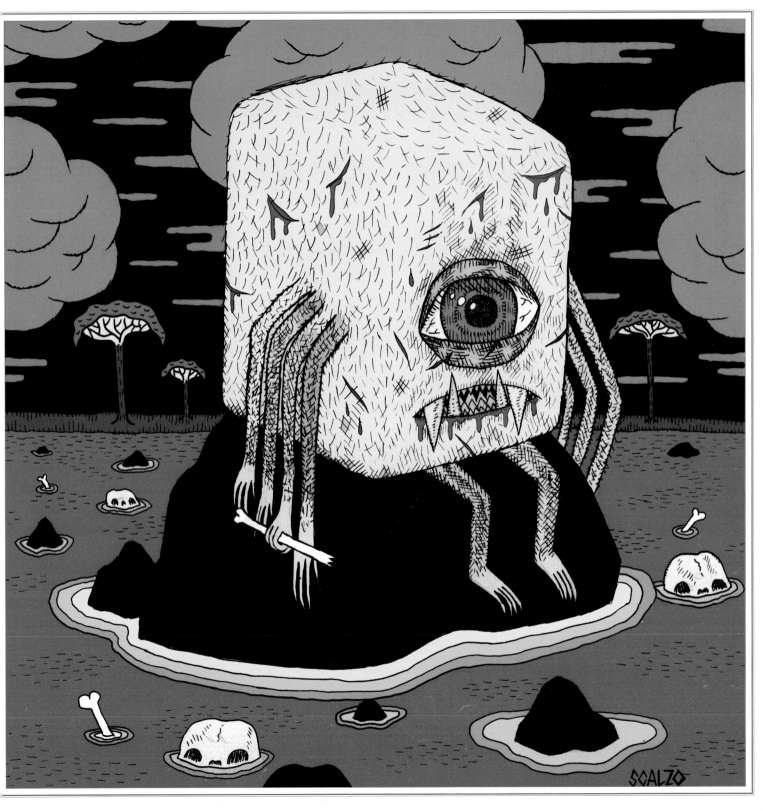

# 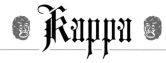 Kappa

KAPPA derive their life force from a fluid-filled basin at the top of their skulls. This greenish aquatic monster of Japan is most frequently described as a tortoise with a child's head (hence its other name, Kawako or "Child of the River") and a bird's beak. Some KAPPA are helpful (offering medical advice), while others are mischievous (peeking up kimonos) or even malicious (devouring children's entrails or sucking their blood). If the creature's disposition tends toward the latter, brave humans can try to charm the KAPPA with its favored snack, the cucumber. Another effective tactic of escape is to offer a low bow, which induces the ever-courteous KAPPA to bow in response and thereby spill its life-sustaining fluid.

Plate 52 . BWANA SPOONS

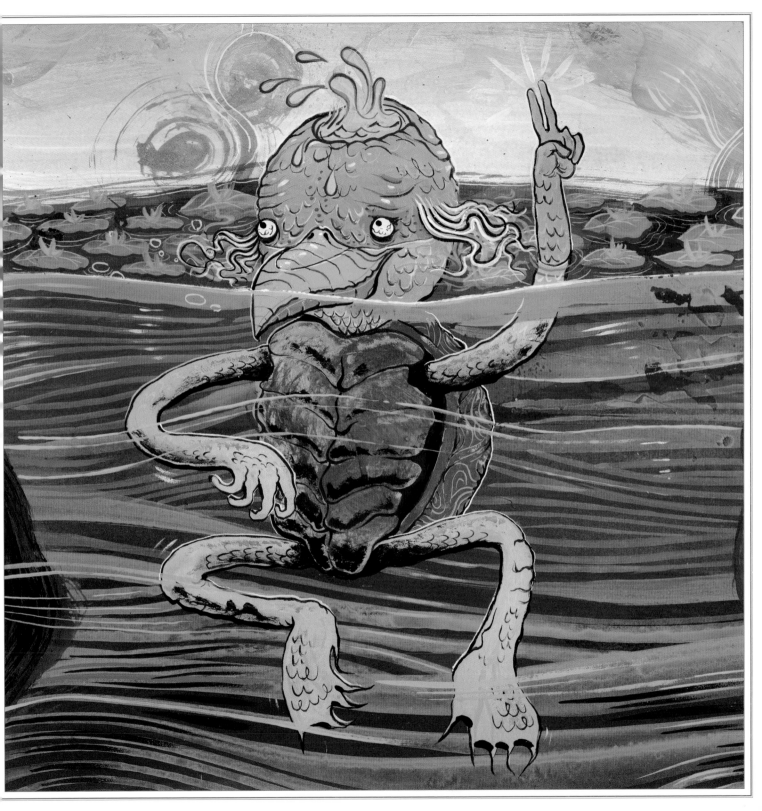

# Kojiki's Yamata no Orochi

This singular curiosity, long believed to be dormant, was last seen in Japan in ancient times and mentioned in the classic scripture *Kojiki*. Its serpentine body was long enough to drape in repose over eight successive hills, which it would do for such great lengths of time that mosses and lichens took up residence on its skin. The **YAMATA NO OROCHI** often demanded tribute in the form of peasant children, enforcing its cruel authority with eight massive sets of jaws (eight heads and eight tails sprouted from its immense trunk). If the monster's jaws weren't enough to frighten its victims into submission, its glare was said to glow with the fierce crimson of a winter cherry. Even the most robust heroes relied on trickery to defeat this intimidating beast. [Editor's Note: See inside back cover]

Plate 53 . MIZNA WADA

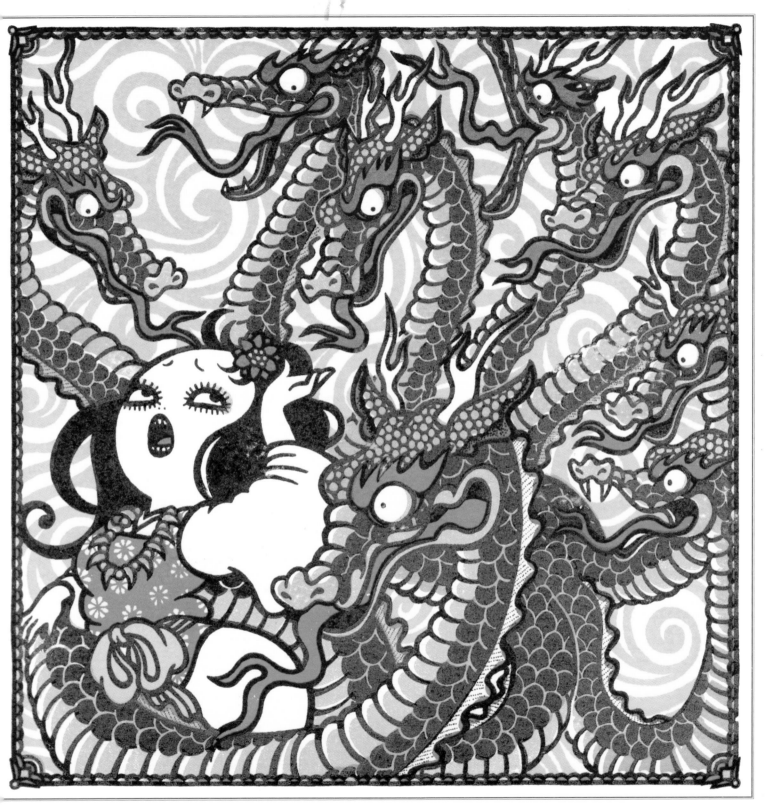

# Kraken

With innumerable tentacles, long enough to reach the top of even a mighty ship's main mast, the **KRAKEN** (also called the Krabben or Crab-Fish) has inspired dread in Scandinavian seafarers for centuries. Even more than its tentacles, though, captains fear the vast whirlpool left behind when the malicious squidlike beast submerges—as well as the ring waves created when it violently resurfaces. Measuring more than a mile across, the **KRAKEN** attracts legions of smaller fish that feed on its leavings. Ambitious fishers who brave the **KRAKEN**'s presence often secure a bountiful catch.

Plate 54 . JEREMY FISH

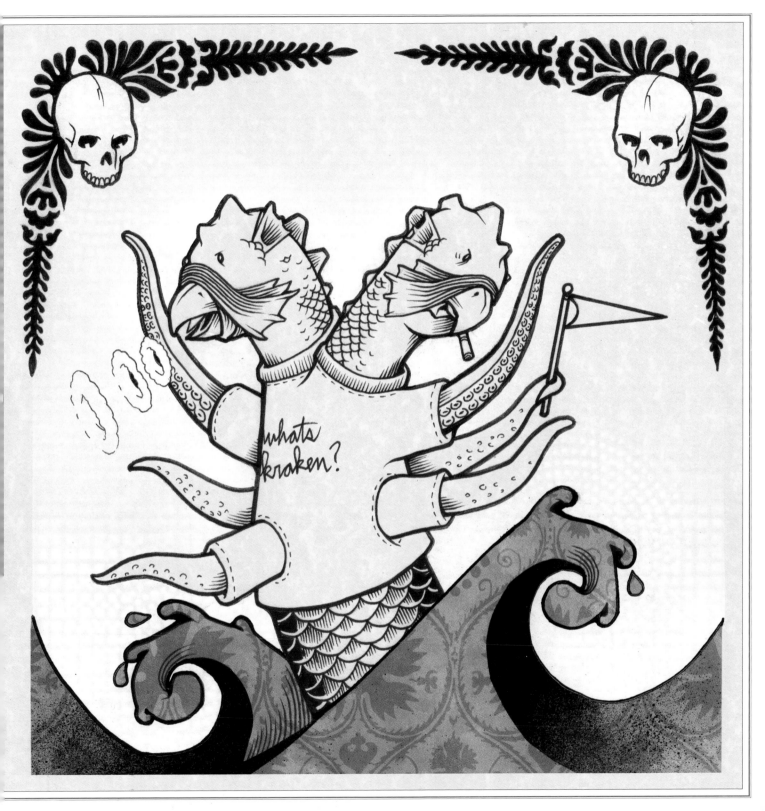

# Kukuweaq

Inspiring fear in the natives of the frozen stretches of North America, this enormous polar-bear monster is as large as several polar bears walking in close tandem and often is known to possess ten stout legs. Its sharp teeth, razor claws, and remarkable speed permit the KUKUWEAQ to easily chase down and kill all but the wiliest prey. The only certain method to dispatch one is to use great stealth (and overwhelming force) while the beast is fishing.

Plate 55 . TYLER STOUT

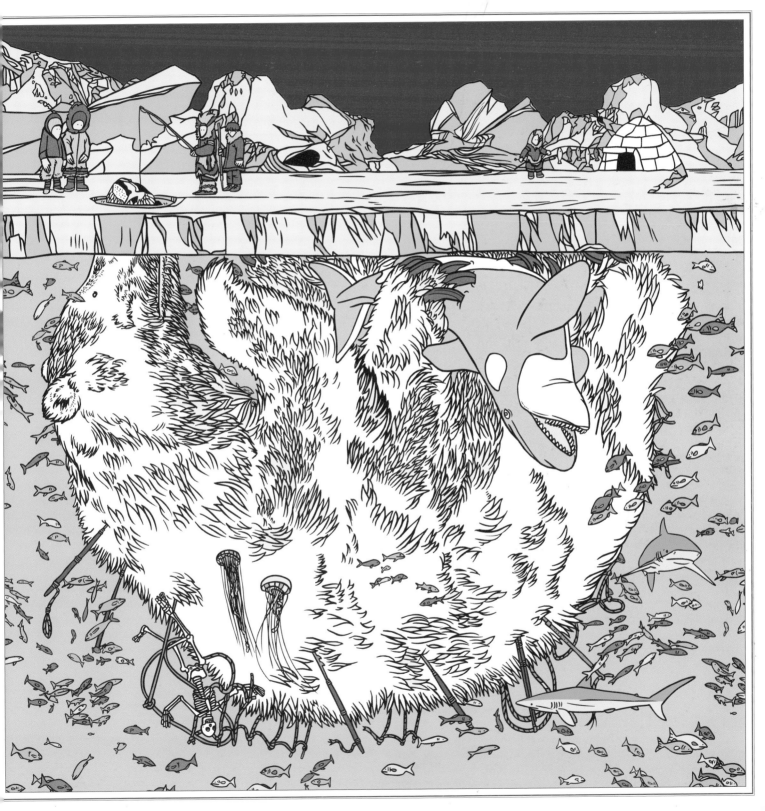

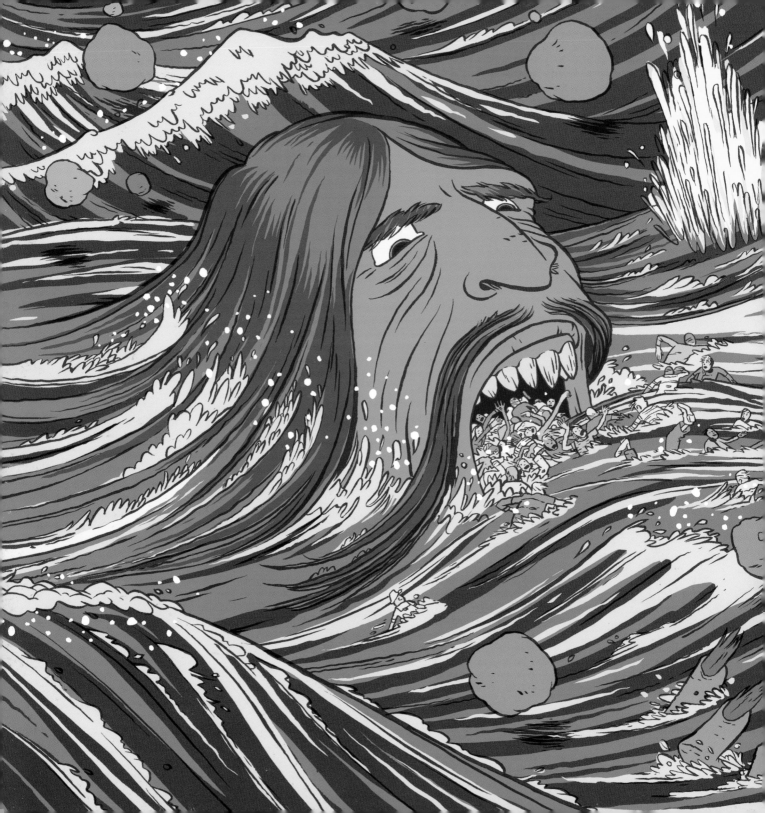

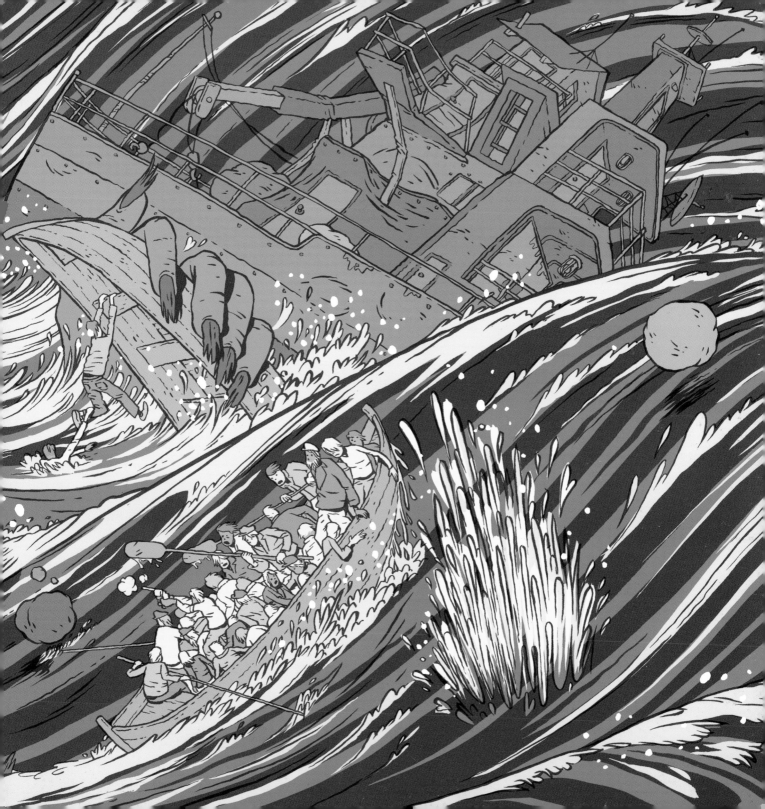

# Laestrygonians

Sequestered on an island stronghold off the coast of Sicily, these man-eating giants lead an industrious but reclusive existence, interrupted only by the occasional landfall of unwitting sailors. Fooled by **LAESTRYGONIAN** children, who are the size of human adults, seafaring visitors to this island often discover the towering (and vicious) nature of its inhabitants too late. Any human caught on the island is torn apart and eaten immediately. The **LAESTRYGONIANS** throw boulders to sink any boats still nearby, swimming out with spears to devour the survivors.

Previous: Plate 56 . JORDAN CRANE

# Leveller

A typical male **LEVELLER** looks rather like a faraway elephant, because it is so much larger than its distant cousin that the unacquainted observer must assume a mistake in judging perspective. With an average weight of 60 tons, as large as the largest meteorite yet found on Earth, it requires nearly 2,000 pounds of vegetation and 500 gallons of fresh water daily. Once a smoother of roads, war-time helper (its tusks are long and sharp), and generally useful work-beast, the eerily green-skinned **LEVELLER** has now fallen into obscurity (and possibly even extinction) thanks to its rather dramatic appetite. Thus we see that each creature has its place in the world and must abide by nature's dictates or perish.

Opposite: Plate 57 . PETER THOMPSON

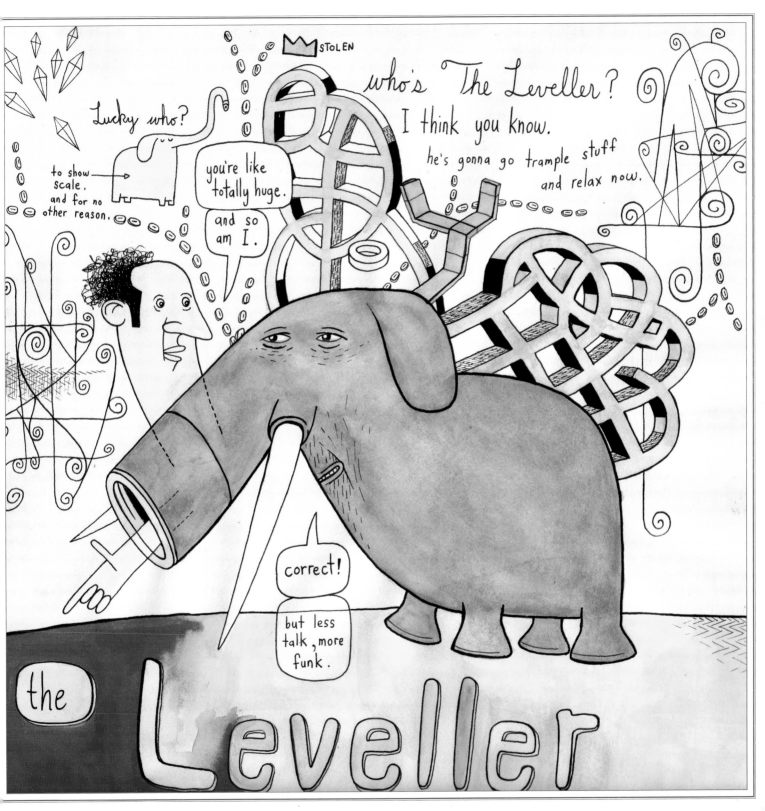

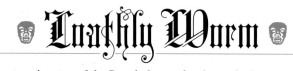

# Loathly Worm

This unwinged variety of the British dragon family wreaks devastation on the lands of Europe, though its territory has diminished significantly of late. Its immensely strong, serpentine body is supported by two small, lizardlike legs (sometimes four in mutant individuals). Though its claws can deliver nasty scratches and cut through flesh with great ease, the **LOATHLY WORM** seems to prefer thrashing prey with its fierce jaws or crushing victims within its massive coils. In ancient times, the **LOATHLY WORM** killed indiscriminately, often leaving bodies strewn about uneaten; it seems to have become much more selective in its attacks.

Plate 58 . SCOTT TEPLIN

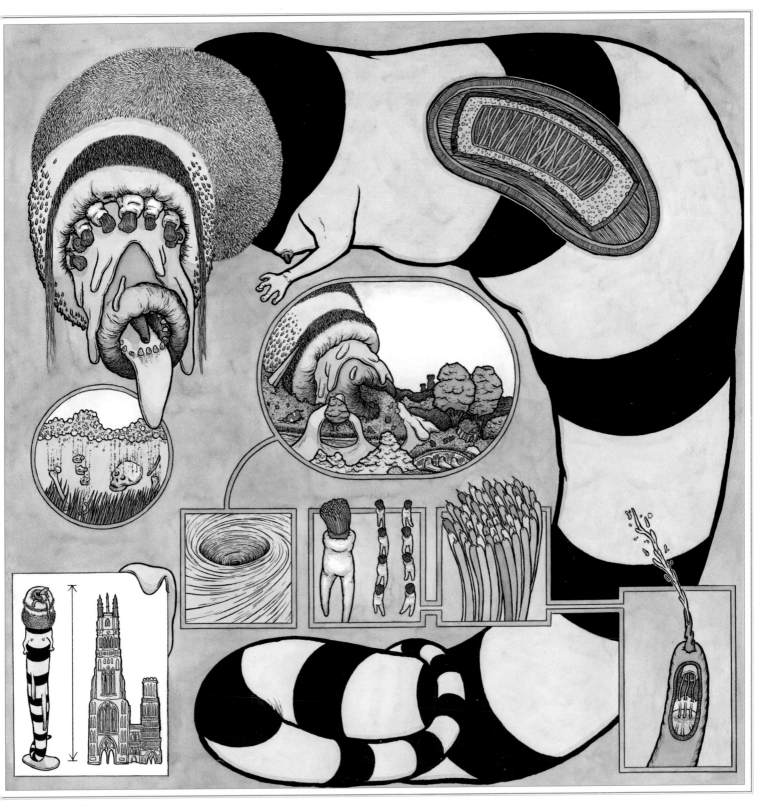

# Loch Ness Monster

Affectionately known as Nessie, the *Nessiteras rhombopteryx* makes its home in the nearly-800-foot-deep Loch Ness of Scotland, a lake connected by rivers to the North Sea and the Atlantic Ocean. Approximately 1500 years ago, a tattoo-covered tribe of Picts etched lakeside stones with pictures of a large water monster resembling a swimming elephant. Over the centuries, sightings of the thin-necked, small-headed creature, perhaps a 30-foot-long serpent or dragon, continued. After a road was built around the lake in 1933, reports and photographs of the seemingly shy beast proliferated. Still, almost nothing is known about the habits of the reclusive, elusive **LOCH NESS MONSTER**.

Plate 59 . MAXWELL LOREN HOLYOKE-HIRSCH

# 𝕷𝖔𝖓𝖌 𝖂𝖆𝖓𝖌

**LONG WANG**, the well-loved Chinese Dragon King, is considered to be the ruler of funerals and rain. If something goes awry during a funeral, or crops are suffering from a drought, **LONG WANG** can be asked for help. A shapeshifter, the dragon itself can turn into rain or take on the form of dewdrops when needed, although more commonly it appears as a fierce, scaly dragon with some combination of tiger's feet, demon's eyes, a camel's head, or horns.

Plate 60 . MARTIN ONTIVEROS

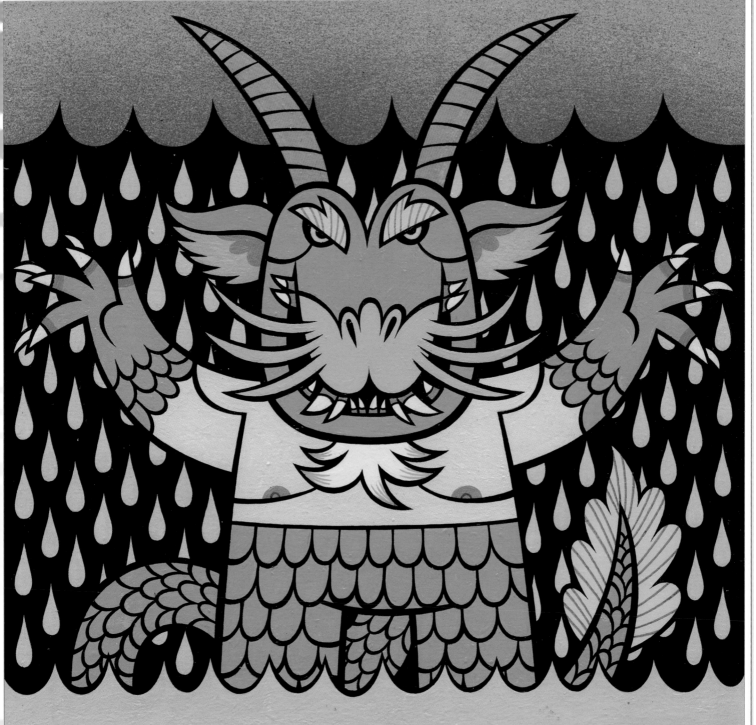

# Lou Carcolh

**LOU CARCOLH** is a monstrous mollusk-serpent that conceals itself underground in French caverns. This enormous troglodyte's mouth is surrounded by a set of long, hairy tentacles, which it can extend for miles to seek out brave spelunkers, or even passersby, and pull them deep into its cave-home. **LOU CARCOLH** slowly tugs its victims through the gelatinous slime that constantly drips from its tentacles, and then it swallows them whole.

Plate 61 . CHRIS RYNIAK

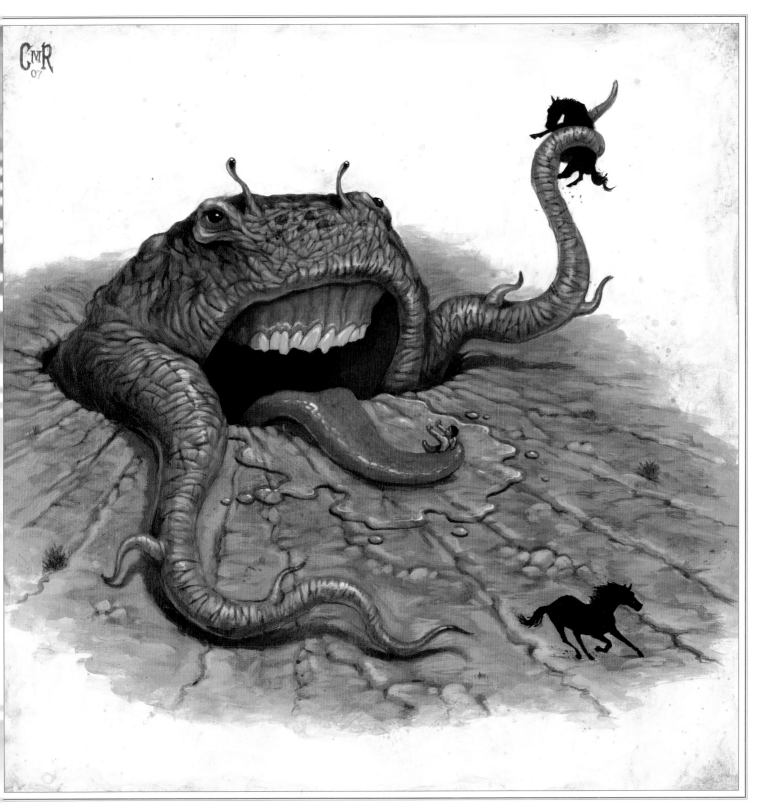

# Manticore

This gigantic, red-pelted, man-headed leonine beast, first seen in India and Ethiopia, has three rows of wicked teeth and enormous claws perfectly suited for rending flesh, but it generally relies on its spiny tail to kill prey. Capable of shooting deadly volleys of these incapacitatingly poisonous quills great distances, the **MANTICORE** can typically dispatch a dozen sheep, goats, or humans before any realize its fierce and desperate assault has begun. Given its size and bright coloration, it seems somewhat anomalous to modern naturalists that the creature should be capable of taking any prey by surprise, even at great range, but somehow the **MANTICORE** endures.

Plate 62 . ANDY KEHOE

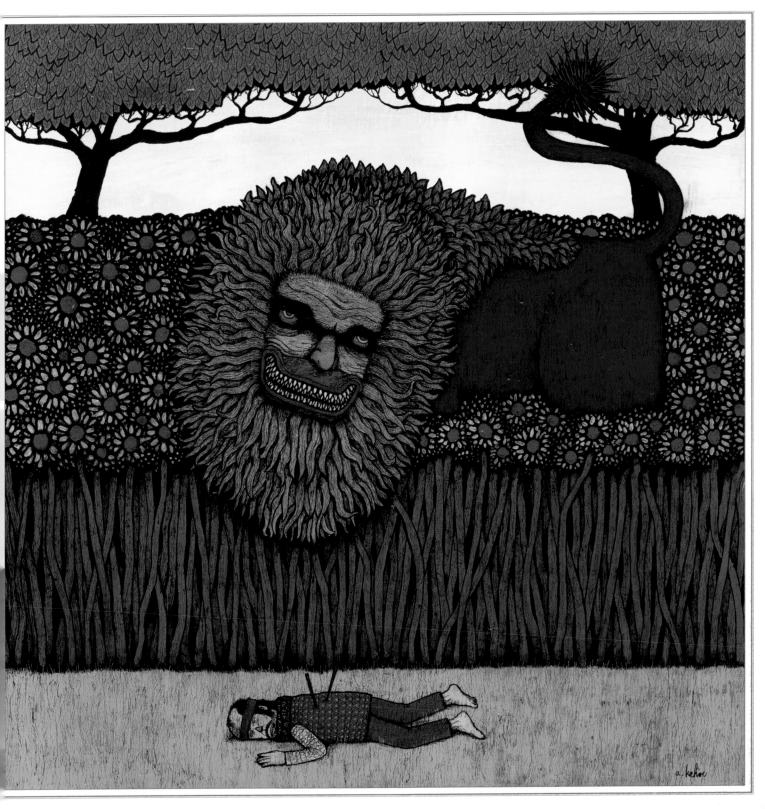

# Melusine

Famed resident of the sacred springs and rivers of France, the mermaid creature **MELUSINE** is a radiant, finely outfitted young woman with a double-forked piscine tail. She has inspired countless tales of hapless human suitors who fall for her beauty only to be rejected. She surfaces briefly every few years holding a golden key in her mouth. When the key is finally claimed by the right man, she will become human, follow him home, and be his bride. Though she has wings, **MELUSINE** does not fly.

Plate 63 . ATTABOY

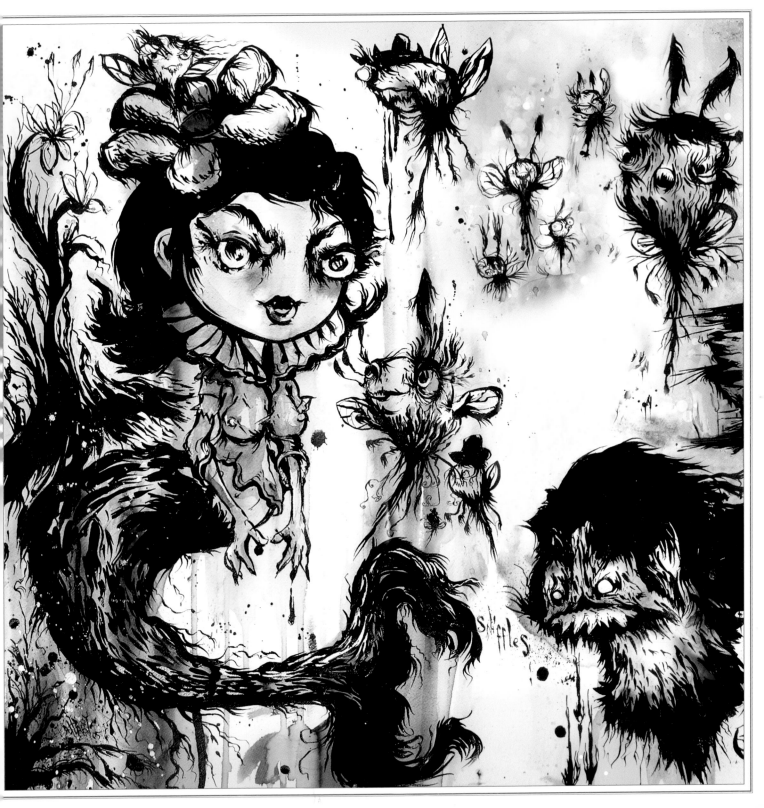

# Mimick Dog

Due to its canine features and apelike disposition, some assume the Egyptian **MIMICK DOG** is a cross between a primate and a poodle. According to the accounts of medieval European travelers, the **MIMICK DOG** has shaggy hair, long legs, and a thick snout, and, like some chimpanzees, the clever beast has the ability to imitate anything it chooses to. Its abundant dancing and acting talent has made the performing pooch a favorite in royal courts, yet peasants throughout history have often enslaved it, keeping the **MIMICK DOG** as either an inexpensive substitute for servants or merely for the sake of entertainment.

Plate 64 . JUSTIN B. WILLIAMS

# Minata-Karaia

These treelike giants live among the tribes of the Mato Grosso in Brazil, their arms stretching high into the rainforest canopy. The **MINATA-KARAIA** are thought to subsist on roughly spherical, thick-husked fruits resembling coconuts, which grow in large bunches from beneath their armpits. To eat the fruits, they pluck them, then break the husks open using their foreheads. All 14,000 other tribes in the area give the **MINATA-KARAIA** a wide berth. This is facilitated by a hole in the head of each **MINATA-KARAIA** male, which produces a shrill whistling noise warning of its approach.

Plate 65 . JEFF SOTO

#  Minotaur

There is only one known **MINOTAUR**, a massive, bull-headed man of great strength, descended from an extraordinary white bull and a beguiled young queen, wife of King Minos of Greece. Shortly after its birth, the hulking **MINOTAUR** was given a huge double-bladed ax and imprisoned in a tortuous labyrinth, where it hunted and devoured humans who had been lowered into the maze as a sacrifice. It is a long story with an unhappy ending, middle, and beginning.

Plate 66 . JASON

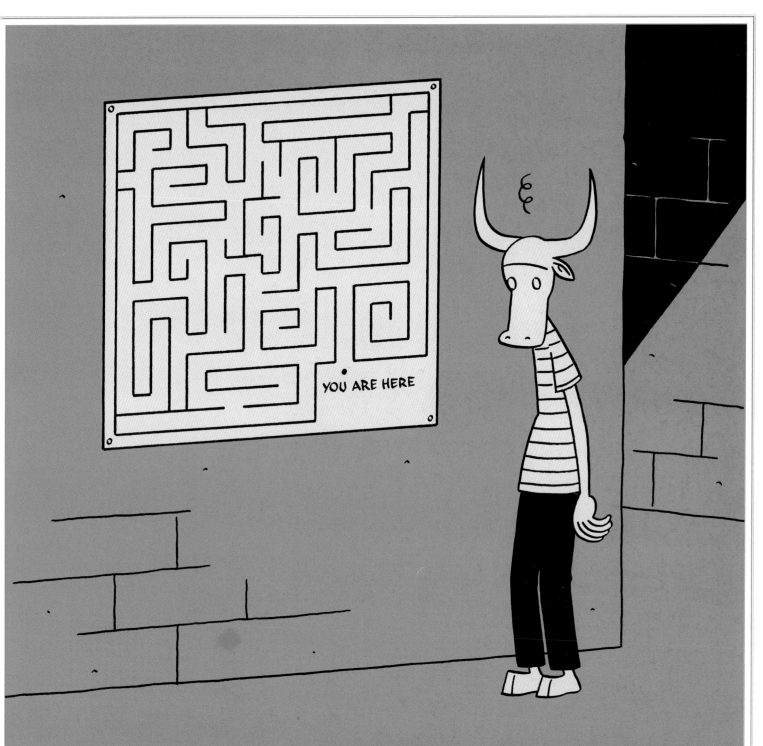

# Monoceros

The word *monoceros* is Greek for "unicorn," and thus this European beast shares its name with land-bound creatures both mundane (the rhinoceros) and fantastic. In the case of the marine **MONOCEROS**, however, there is no comparison: the creature's horned head may resemble that of a common unicorn, but its proportions are gargantuan. Its scaled, serpentine tail is likewise monstrous and huge. Known to lurk beneath castles and other size-able seaside structures, the **MONOCEROS** favors the flesh of the young.

Plate 67 . JESSICA LYNCH

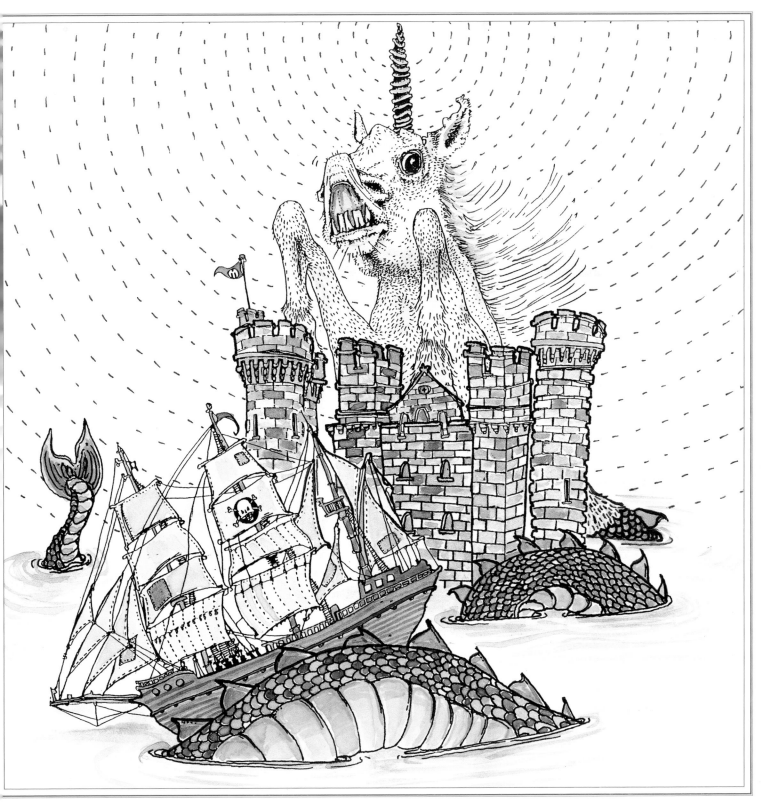

# 𝕹uckalevee

Some creatures warrant greater respect or fear than others, and the NUCKA-LEVEE of the Irish Sea demands its share of each. If some mad anatomist were to stitch together the torso of a large man and the lower parts of a horse—and then to flay the skin entirely—the result would strongly resemble this incredibly foul beast. The NUCKALEVEE has been known to follow unfortunates far inland, seemingly delighting in its victims' torment, but it will never cross fresh water, allowing some to make their escapes. One little understood aspect of the NUCKALEVEE is its breath, which is said to stink worse than the grave and to infect those in its range with the plague. Much remains to be learned about this puzzling beast.

Plate 68 . NATHAN HUANG

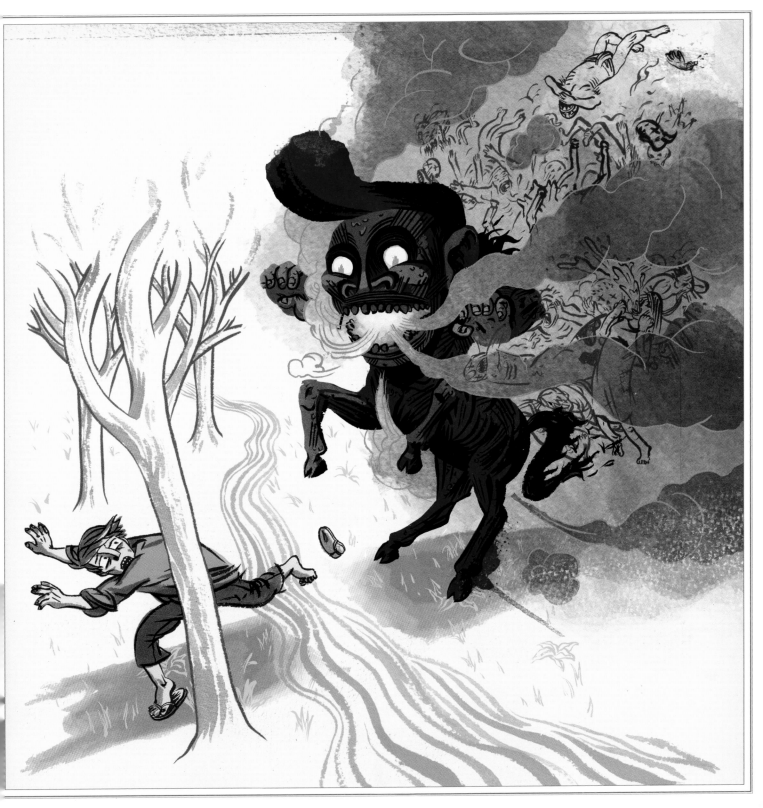

# Odontotyrannus

This amphibious, human-eating monster of India is said to be so large that it could swallow an unlucky elephant whole. The three horns atop the **ODON-TOTYRANNUS'** head are more for show than for combat, as its fearsome claws and teeth alone could swiftly destroy any enemy. The **ODONTOTYRANNUS** rarely leaves its watery home in the Ganges River except in times of great turmoil. Those who encounter it on dry land must make haste for a nearby cavern, lest they find themselves devoured.

Plate 69 . KEVIN DART

See the TERRIBLE BEAST gorge himself on INNOCENT BEACH-GOERS!

Will the BEACHES ever be SAFE AGAIN?

TOJO STUDIOS PRESENTS

ATTACK OF ODONTO TYRANNUS

#  Pegasus

**PEGASUS** is a striking white stallion of Greek origin with sweeping gold wings that flies with remarkable grace and speed. Few have dared to tame this creature, none without help, and at least one unlucky rider has been thrown to his death by the willful steed. Rumors persist that wherever the hooves of **PEGASUS** touch solid rock, a spring bursts forth. This may account for the formation of Mt. Helicon's Hippocrene spring, a well-known inspiration for poets and other artists.

**Plate 70 . JESSE RENO**

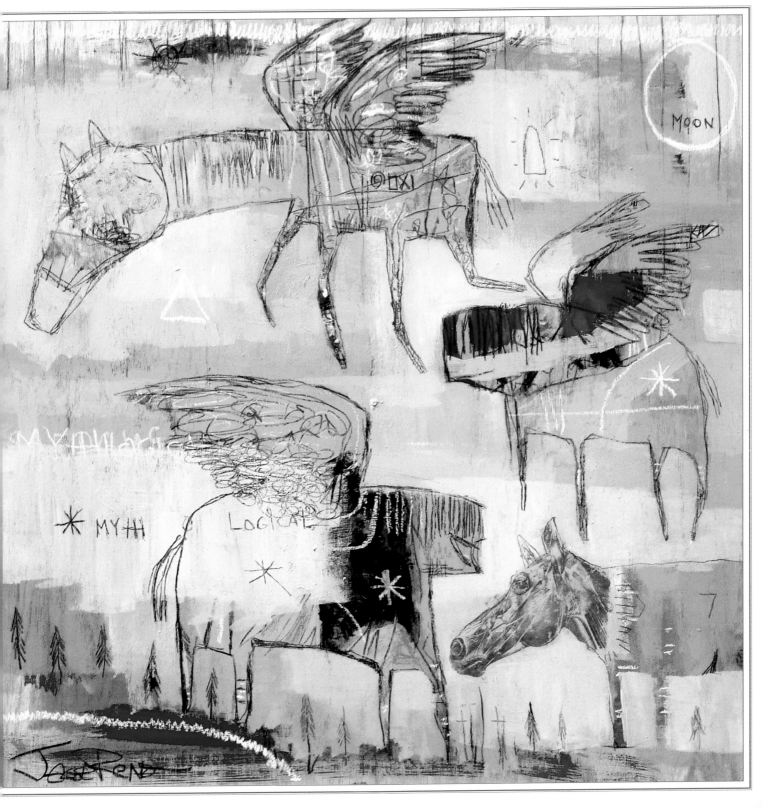

#  Pey

These shaggy-haired, humanlike monsters are well known throughout southern Asia and rightly feared for their unquenchable thirst for blood. **PEY** particularly enjoy lurking about the fringes of battlefields, drinking the life from dying soldiers and striking fear into the hearts of those forced to rout or otherwise retreat. They can be differentiated from other ghouls of war by their strong, tusklike teeth and their fondness for cultivating long, upturned mustaches.

Plate 71 . STEVEN WEISSMAN

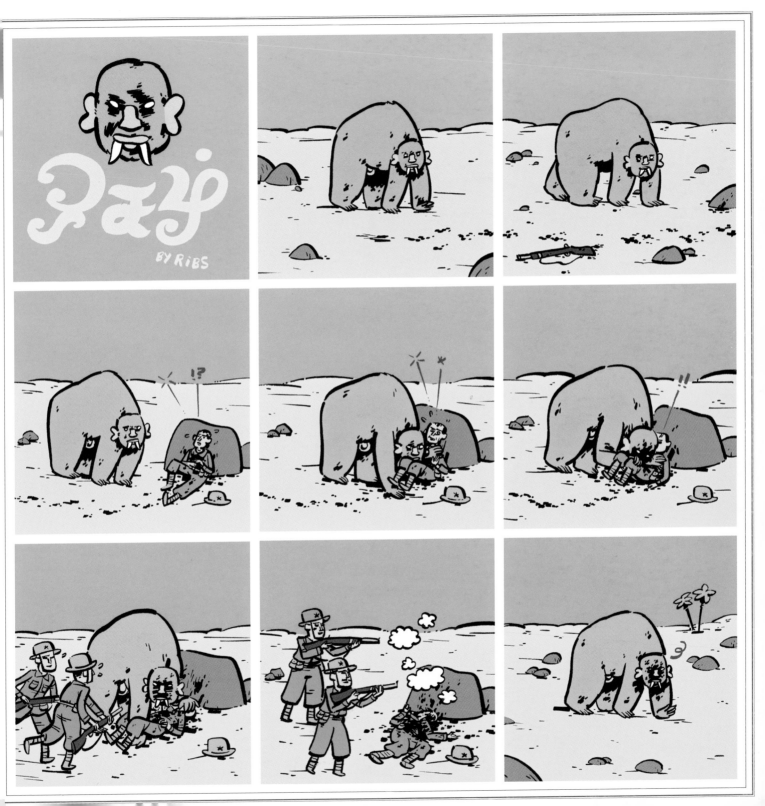

# Puk

A **PUK** is a useful household dragon sometimes found in Germany, Scandinavia, and Great Britain. This serpent-bodied, winged quadruped stretches only about two feet in length but often displays a fiery tail. Thievery is its primary vocation: it steals treasure, then meticulously guards it for its master alone. A **PUK** can be bought, bred, or stolen and moved from house to house, and remains completely loyal to whichever master takes it in as a pet or servant.

Plate 72 . ALAN MOOERS

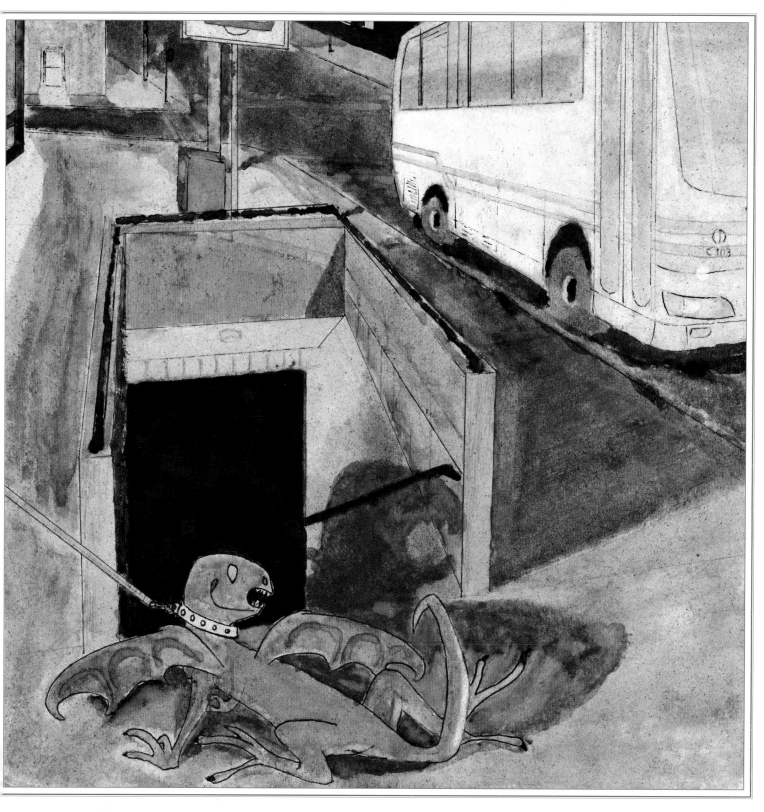

#  Sianach

The gigantic **SIANACH** resides among its deer cousins in the forested Scottish highlands. Though it vaguely shares the form of a deer, it is famously aggressive and predatory. Even the mention of this demonic cervid's name (which translates simply as "monster") chills the hearts of hunters who have heard rumors of its awesome size and murderousness. In truth, this deer-demon has never actually been seen, as humans do not seek it out for fear of being attacked, eaten, or worse.

Plate 73 . ANDERS NILSEN

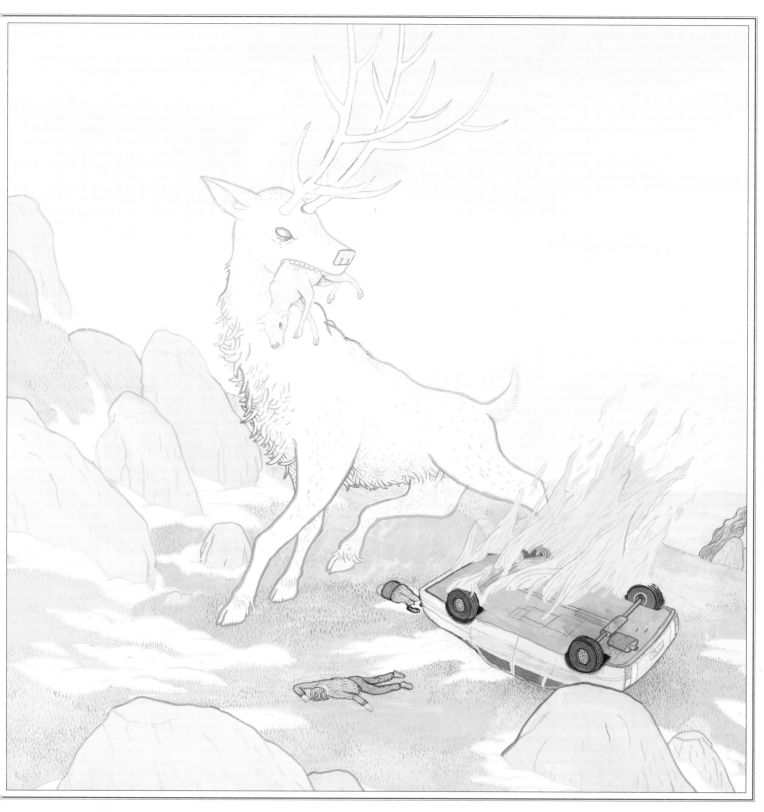

# Siren

These sweetly singing female creatures, first discovered by the Greeks, live exclusively on islands and are chiefly known for using their mellifluous voices to lure sailors to their doom. Conflicting reports give them the hindquarters of fish or seabirds, but all agree that their foreparts resemble those of human women. The song of the SIREN is so compelling that any who hear it must move toward its source as quickly as possible—there to be torn apart and devoured by the singers. While worse fates are certainly possible for those who make their lives on the sea, SIRENS add the ignominy of moral weakness to the terror of an early death.

Plate 74 . TED JOUFLAS

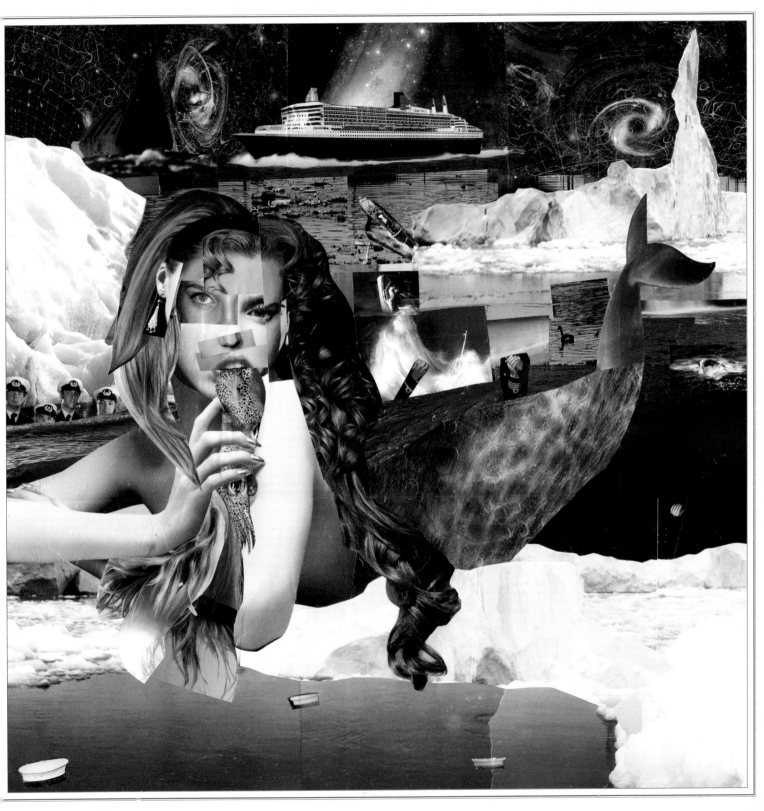

#  Sphinx

This noblest and most regal of all beasts, notably glorified in stone as the Great SPHINX of Giza of Egypt, bears the enormous head (and occasionally the torso) of a man and the body of a lion. Some are winged. A small number, confined to a tightly enclosed region of the Middle East, possess the heads of rams or falcons; these are considered by experts to be degenerate creatures. Thoughtful and composed, a true SPHINX tends to stay in one place for great lengths of time, giving rise to speculation that it need not eat. The Greek word *sphinx* (for it was the Greeks who first studied the beast systematically) translates as "strangler," since the SPHINX would strangle anyone unable to answer history's most famous riddle*.

*Which creature in the morning goes on four feet, at noon on two, and in the evening upon three?*

Plate 75 . FOI JIMENEZ

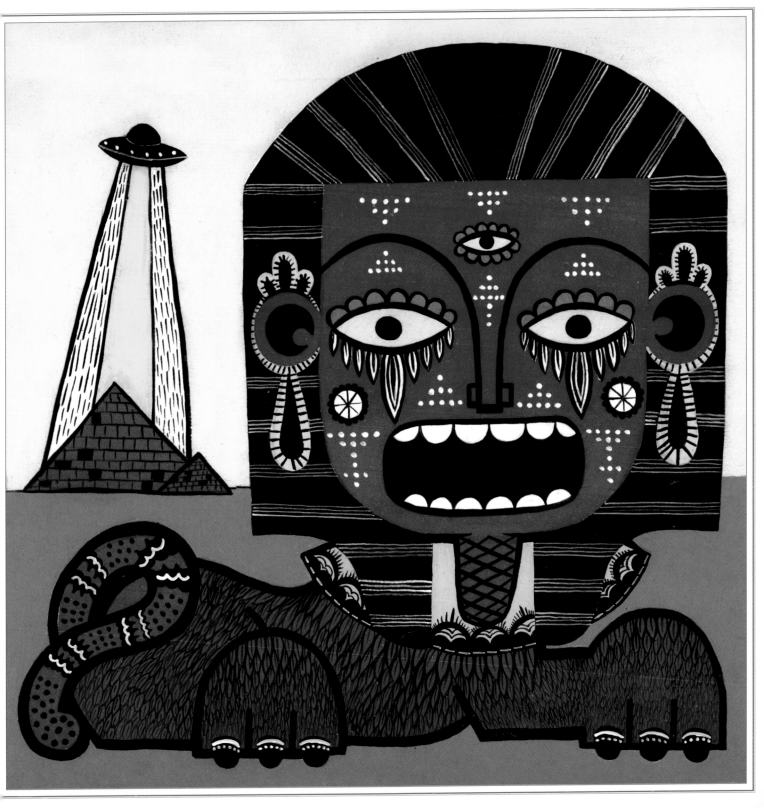

# ᛋᚢᚳᚳᚢᛒᚢᛋ Succubus

These breathtakingly beautiful female demons of European origin delight in the nighttime seduction of the otherwise chaste, whom they visit lasciviously in lengthy dreams. (The word *succubus* comes from the Latin *sub-cubare*, which means "to lie under.") Someone in the thrall of a SUCCUBUS will wake up fatigued, often to the point of exhaustion. Victims might also experience inexplicable feelings of shame upon rising, even though they have no memory of their nocturnal orgies. Although the prey of a SUCCUBUS is generally thought to be virtuous, the creature can only subsist on those with great longing or lust.

Plate 76 . JAMES JEAN

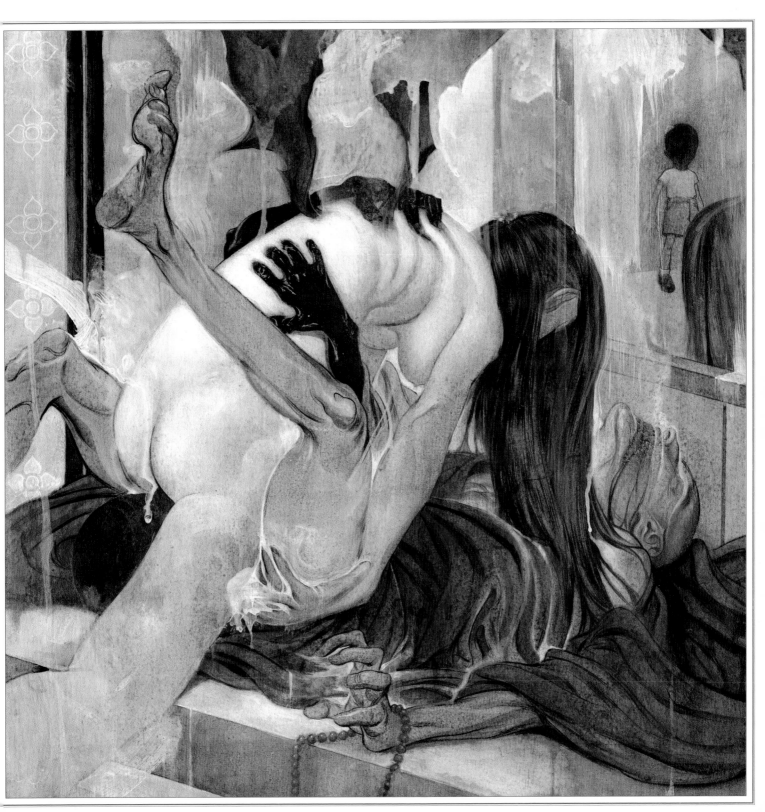

# 𝕿𝖍𝖚𝖓𝖉𝖊𝖗𝖇𝖊𝖆𝖘𝖙

Often appearing in the form of a weasel, badger, monkey, or tanuki, this Japanese demon is usually gentle and harmless. During violent storms, however, the **THUNDERBEAST** (or Raiju) displays severe agitation. Its body becomes consumed in fire or lightning as it streaks around, leaping between trees, rocks, and buildings. It is said that the **THUNDERBEAST** will sometimes take refuge—and even nap—in the navels of humans. Because the **THUNDERBEAST** tends to attract lightning, people familiar with its tendencies choose to sleep on their stomachs during inclement weather.

Plate 77 . JAY RYAN

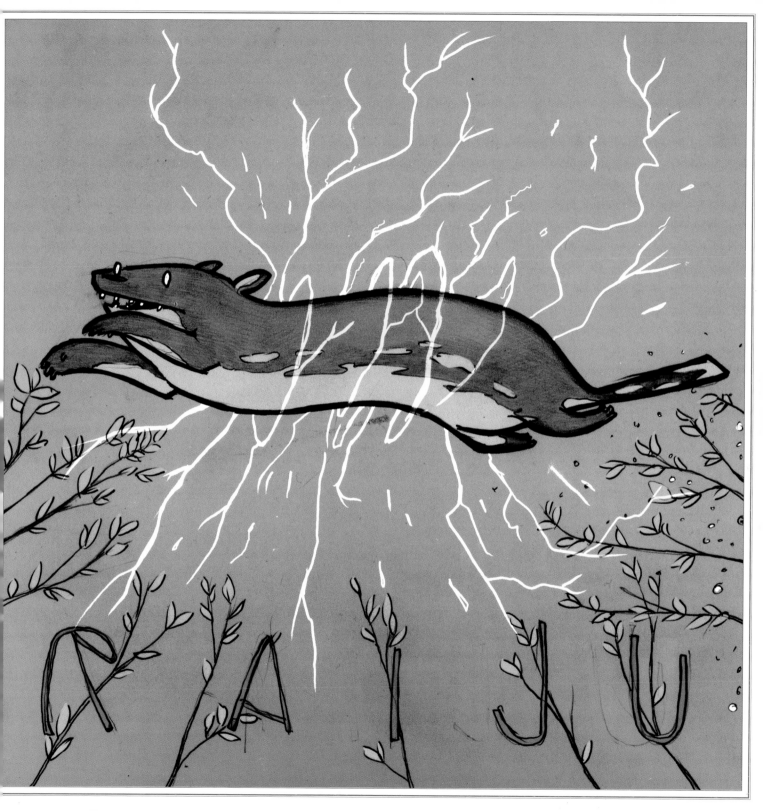

# Thunderbird & Uncegila

Few beings share a rivalry as heated or longstanding as that between the THUNDER-BIRD and the UNCEGILA (pronounced *oo-chay-gee-la*). The THUNDERBIRD is a huge eagle said to delight in both fighting and noble deeds, while the UNCEGILA is a huge, sickly green serpent with scales made of flint and eyes that shoot flame. Respectively revered and feared by the Lakota Sioux, the THUNDERBIRD and UNCEGILA wage war at extremely high altitudes. The THUNDERBIRD stands vigilant guard as the snaky UNCEGILA attempts to attack, and each time the THUNDERBIRD succeeds in rebuffing UNCEGILA's approach, a sound is created by the beating of its wings (which is often mistaken for thunder, hence "thunderbird").

Plate 78 . JASON MILES

THUNDERBIRD UNCEGILA

Leviathan–Whale
observ'd by Capt.
Stodge Rimperton of
the whaling brig
"Mercy Josephine"
March 10, 1856

approx. 75 yards in
length, estimated at 400 tons

It was noted that the
monstre was equipped
with gills as well
as double spouts

It was spotted off the coast of
Cape Ann, Massachusetts
where it rammed the ship and
devour'd two
crew members

75 yds

20 yds

75 yds

Crew perished:

Drinkative Crowe
"Uncle Jack" Cabby

Additional sketches

Cn. S. Rimperton

# Leviathan

This titanic being, known since biblical times, was once said to encompass the great vastness under all of the world's seas. This rather charming but unscientific idea has given way to the more realistic portrait of the **LEVIATHAN** as a sort of whale—but one so large it dwarfs even the Great Blue Whale. Its respiratory system is so powerful that it requires two blowholes to maintain efficient operation; its songs are said to be of surpassing loveliness (and volume). In modern Hebrew, *leviathan* actually means "whale," but the word has evolved as a sweeping term for any biggish beast.

Previous: Plate 79 . TONY MILLIONAIRE

# Triton

Eyewitness accounts of this fierce merman subrace of Greek origin vary a great deal, though all agree they are a lascivious and deceptive lot, much like the Sirens, their female counterparts. The **TRITONS** are known to have humanoid torsos, heads, and limbs. Some, however, describe a single or twin tail, like that of a fish, while others tell of horse-legs on either side of a broad dolphin tail (not to be confused with the horse forelegs of the Ichthyocentaur). Still others claim that **TRITONS** are not human-sized but in fact gargantuan. Most of them ride the waves on horses (or sea monsters) and carry large conch-shell horns, which they use to soothe unruly waters, or, more likely, to upset ships that sail upon them.

Opposite: Plate 80 . JOSH COCHRAN

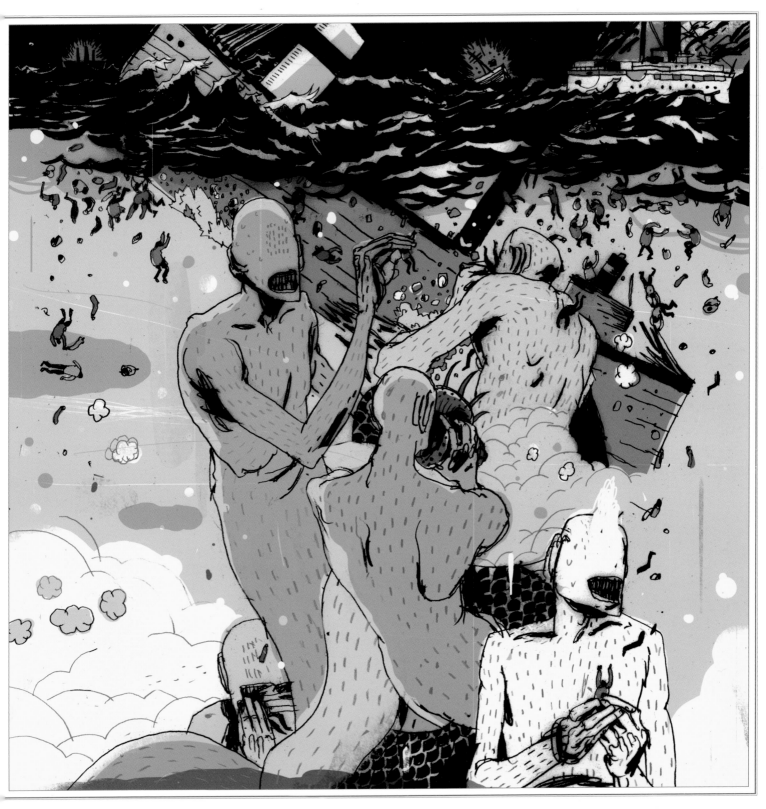

# Troll

A revolting figure in many northern European tales, the **TROLL** is largely solitary, exceedingly dense, and sluggishly malevolent. They prefer to dine on passing animals or travelers who happen upon their isolated quarters under bridges, on stony mountainsides or, occasionally, in forested hills. Though at times their lethargy may drive them to cannibalism, they also venture into towns to nab children or the weak. Peerlessly repellent, **TROLLS** have been known to render local livestock barren and flora wilted.

Plate 81 . S.britt

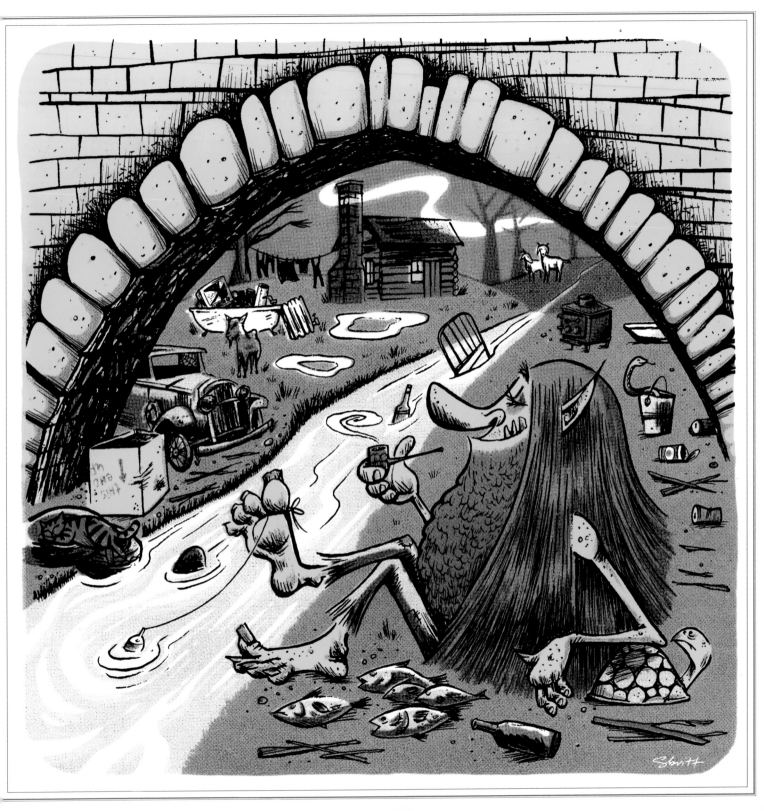

# Tui Delai Gau

This tree-dwelling giant is native to the islands of the South Pacific and is notoriously slothful. Should it grow hungry during one of its marathon naps, the gentle giant merely detaches one of its hands and sends it off to fish, rather than raise its enormous bulk from its resting place high in the trees or somewhere equally comfortable. Similarly, should the **TUI DELAI GAU** grow curious about distant sounds or events, but not wish to move closer to investigate, it will detach its head and raise it high above its body, so that it may continue to lie in repose until it decides whether to employ defense or flight.

Plate 82 . STELLA IM HULTBERG

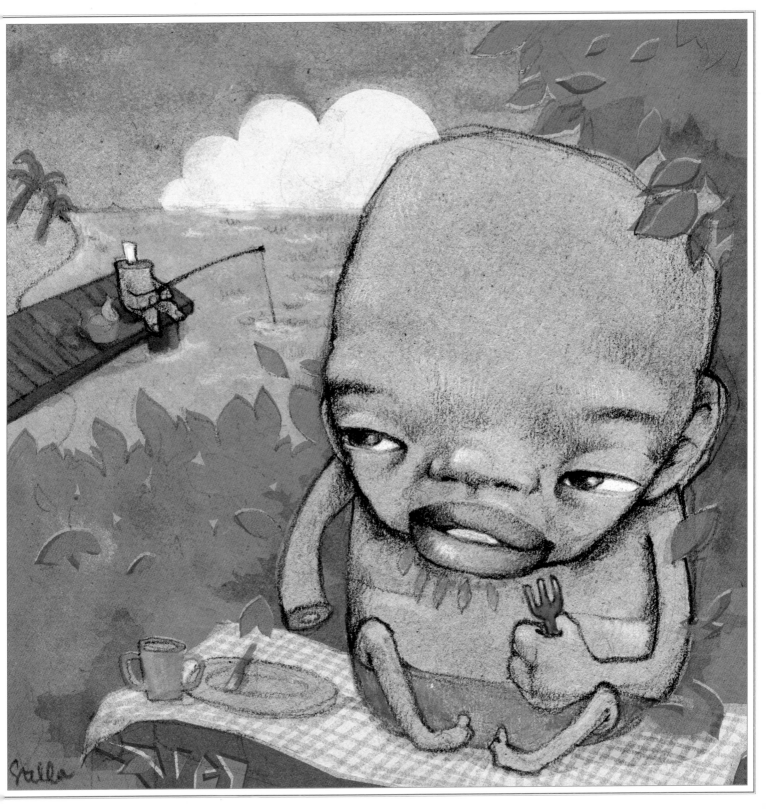

# Unicorn

Benevolent from a distance, stubborn and fierce when pursued, the curious UNICORN is one of nature's most beloved creatures. Resembling a perfectly beautiful white horse with a single spiraling horn upon its alabaster brow, the elusive beast has been represented in ancient cave drawings in France, South America, and parts of southern Africa. Modern cultural references inexplicably link them with rainbows. Schemers seeking the UNICORN's capture in order to steal its healing, allegedly virility-enhancing horn have tried to lure the legendary beast with virgin girls, said to be the only thing that could attract and tame it. All such attempts to date have been unsuccessful.

Plate 83 . SEONNA HONG

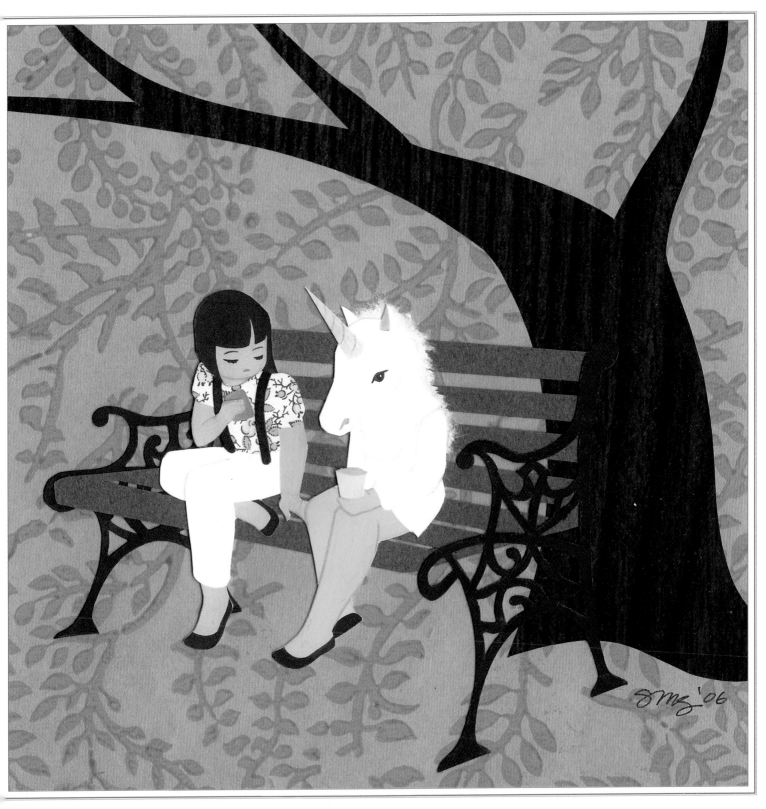

#  Utukku

This thoroughly malevolent creature infests caverns, ruins, and other out-of-the-way locations throughout the Middle East, and will not hesitate to waylay and devour anyone who strays too near. While its body resembles that of a human (though bearing great claws and horns), the UTUKKU's head can be similar to that of a fierce predator animal, with glowing eyes and the stench of death on its lips. They are widely believed by scholars to be a degenerate race, once descended from virtuous beings but gradually becoming feral and monstrous over the centuries. If any still exist, it is likely that their numbers are dwindling quickly.

Plate 84 . SAMMY HARKHAM

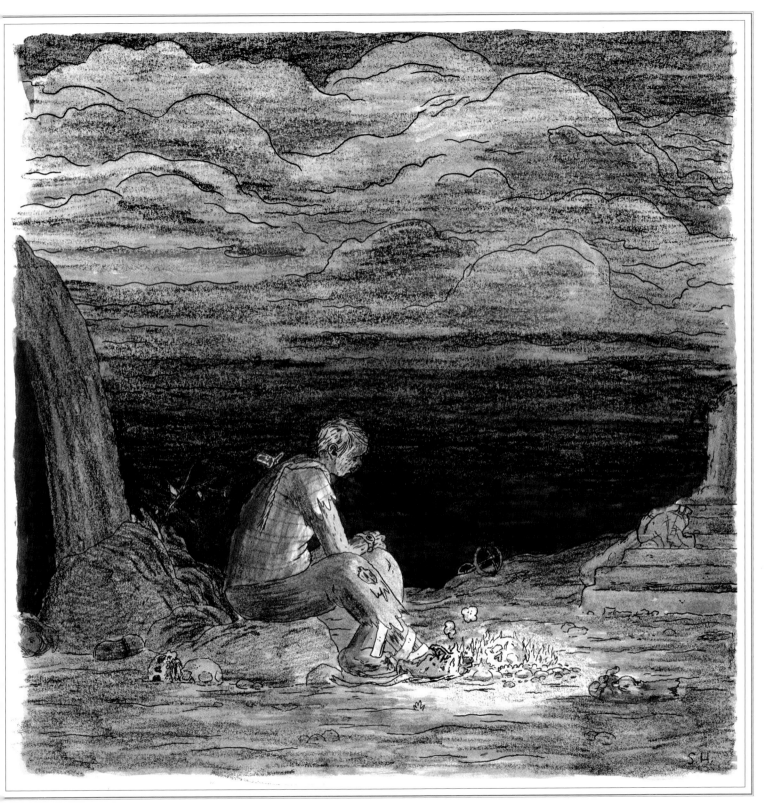

#  Vampire

VAMPIRES, like rats, make their homes wherever humans dwell. Feeding exclusively on human blood, they often inhabit graveyards and other quiet areas near populated settlements. Appearing in the Western world as gaunt, pale humans, often with pronounced canine teeth and long, sharp fingernails, VAMPIRES would be formidable even without their arsenal of uncanny powers, including a hypnotic gaze, vast strength, and the ability to change into a bat or wolf. VAMPIRES in different parts of the world have evolved into various subspecies with rather distinct behavior and appearance; travelers are advised to seek further information prior to departure.

Plate 85 . SAM WEBER

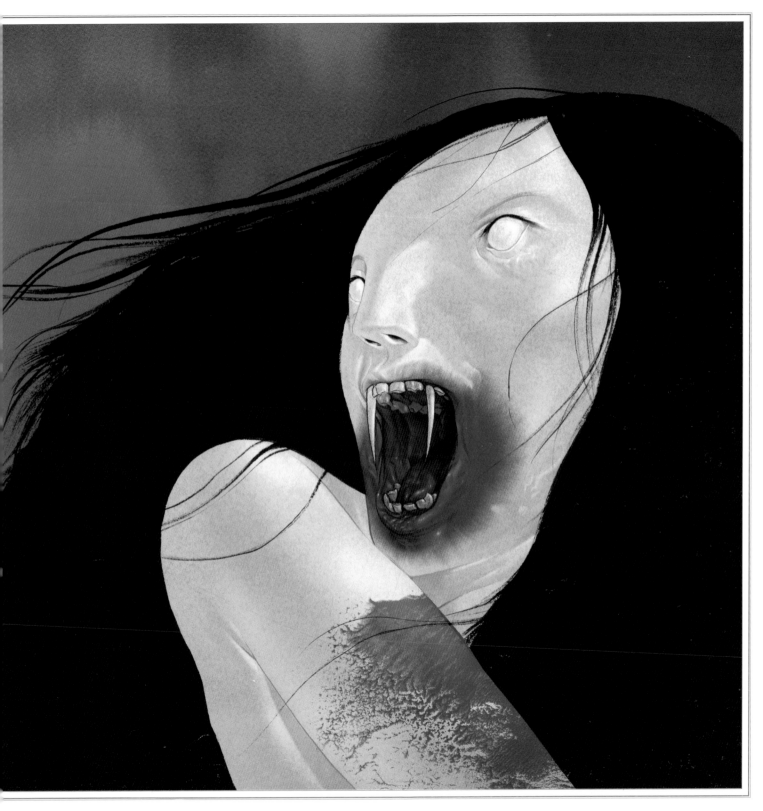

#  Vodnik

Scholarly questions about the **VODNIK** chiefly relate to its appearance. Is it a floating log? An enormous fish? A manlike tadpole? A green-haired human? No matter which shape this Russian water demon, also called Vodjanoy, assumes, it almost always swallows whole those who attempt to study it closely. This loathsome, sharp-clawed freshwater creature is found chiefly in the vast, cold stretches of northern Eurasia as far south and west as the Balkans, setting up residence in pools, cisterns, and other still, quiet bodies of water. Some Slavic villagers say that a **VODNIK** is born when a child drowns, and exists only to drown other unfortunates.

Plate 86 . RICHARD SALA

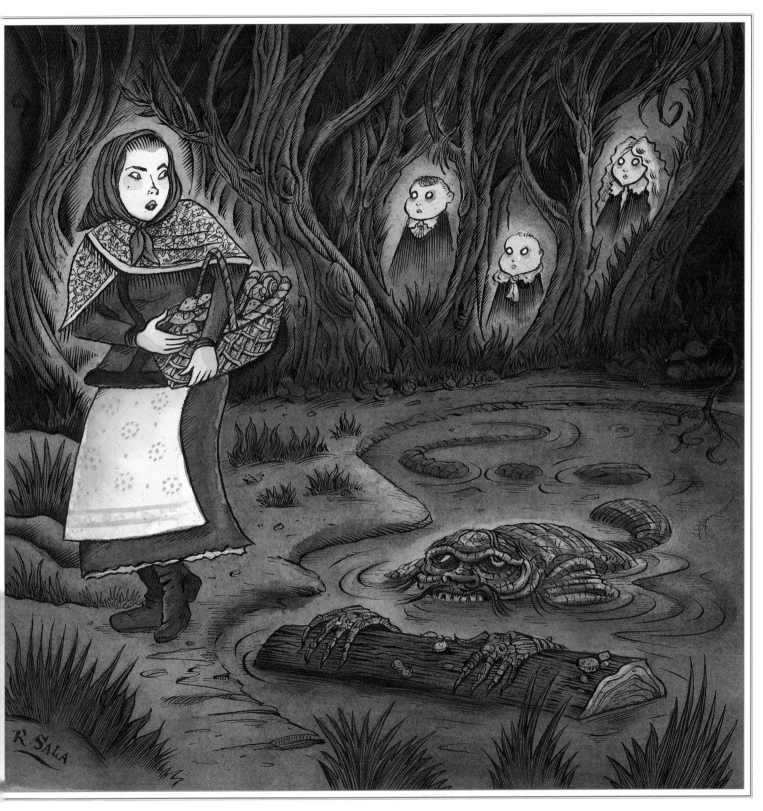

# Werewolf

The confused, carnivorous wolf-man of European origin has found it challenging to reside peaceably among humans, even though every **WEREWOLF** was once human itself. Transformed by curse or other unusual circumstance to lupine form (some **WEREWOLVES** were humans who practiced bestiality, then morphed at death), the **WEREWOLF** suffers from a curious hunger for its former speciesmates. Still, the wilder lifestyle must bear some appeal—enterprising humans who have tired of society's complexities sometimes purposely transform themselves into **WEREWOLVES** through initiation rites, such as wearing a wolf pelt or eating wolf brains. Though many were-creatures are said to exist, **WEREWOLVES** consistently exceed their peers—the were-bear, were-fox, were-hare, were-jaguar, and were-crocodile—in both frequency and renown.

Plate 87 . CHRIS SILAS NEAL

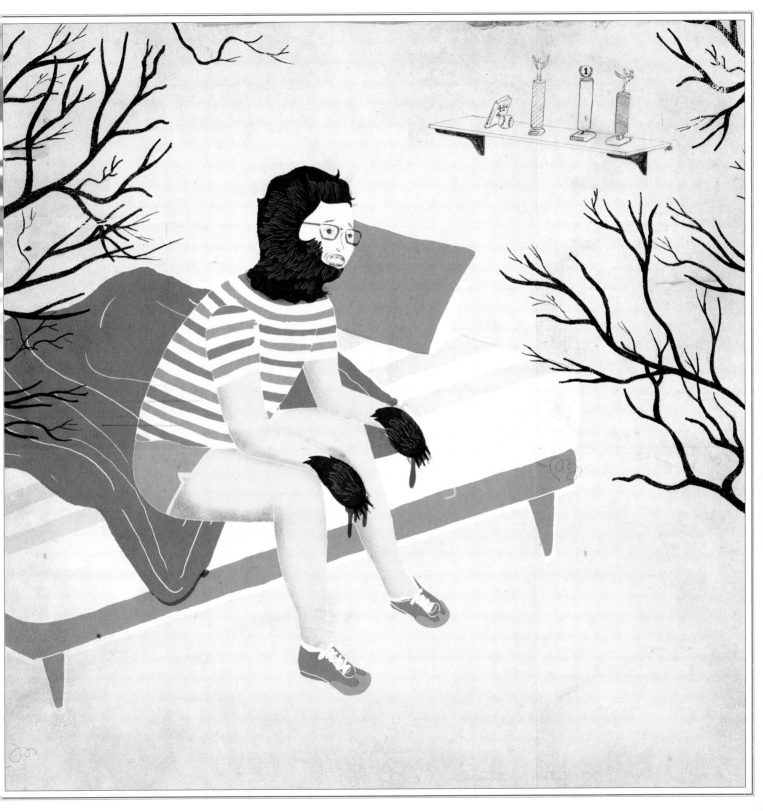

# Wihwin

The bloodthirsty **WIHWIN** swims the waters of the Caribbean, coming ashore to gorge on human prey only in the late summer. Its most intense predation occurs over a small range confined to eastern Nicaragua and northeastern Honduras. The long fangs of the outsized equine creature alarm the inhabitants of this area for obvious reasons. Many simply seek shelter while the **WIHWIN** hunts, waiting for the rainy season when the beast returns to the sea.

Plate 88 . JOE VAUX

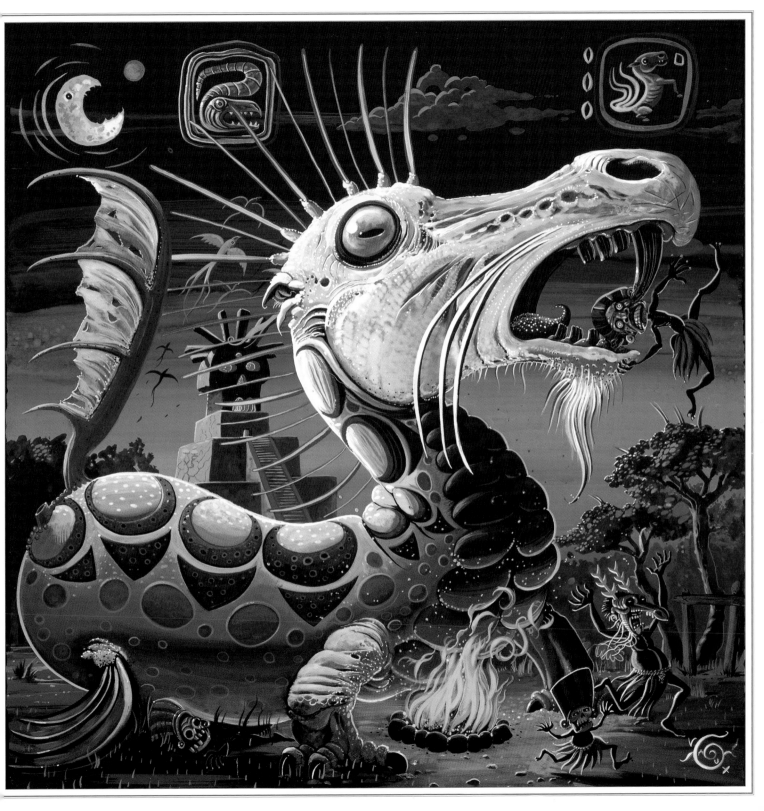

# Wizard's Shackle

This large leechlike creature, also known as the Burach Bhadi, is (fortunately) limited to the shallow waters of Scotland. It chiefly loves to devour horseflesh, so equestrians in that region are advised to take great care when fording rivers, lest the **WIZARD'S SHACKLE** catch the horse's scent, attach itself to its hooves, drown the horse, and suck its blood. Though the **WIZARD'S SHACKLE** has nine eyes on its head, the power and depth of its vision are unknown to experts in the field.

Plate 89 . TOM GAULD

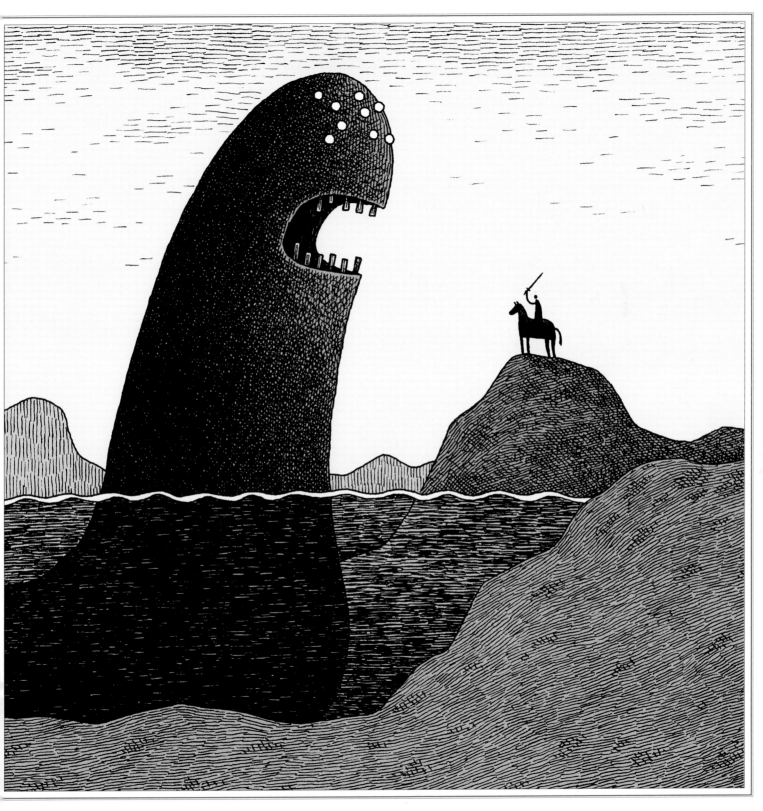

# Wolpertinger

Not to be confused with the fictitious jackalope, the reclusive **WOLPERTINGER** resides in the alpine forests of Bavaria. Its body resembles that of a small squirrel or hare, but its fangs, antlers, and batlike wings distinguish it from its more unassuming rodent peers. While generally peaceful, the **WOLPERTINGER** can be roused to anger. Those unlucky enough to come into direct contact with the beast (and survive) are said to carry its scent for exactly seven years. The origin of its name is unclear, although it may reference the town of Wolterdinger, where Bavarian glassblowers once made animal-shaped glasses called *Schnappshunde* or "schnapps dogs."

Plate 90 . HEIKO MÜLLER

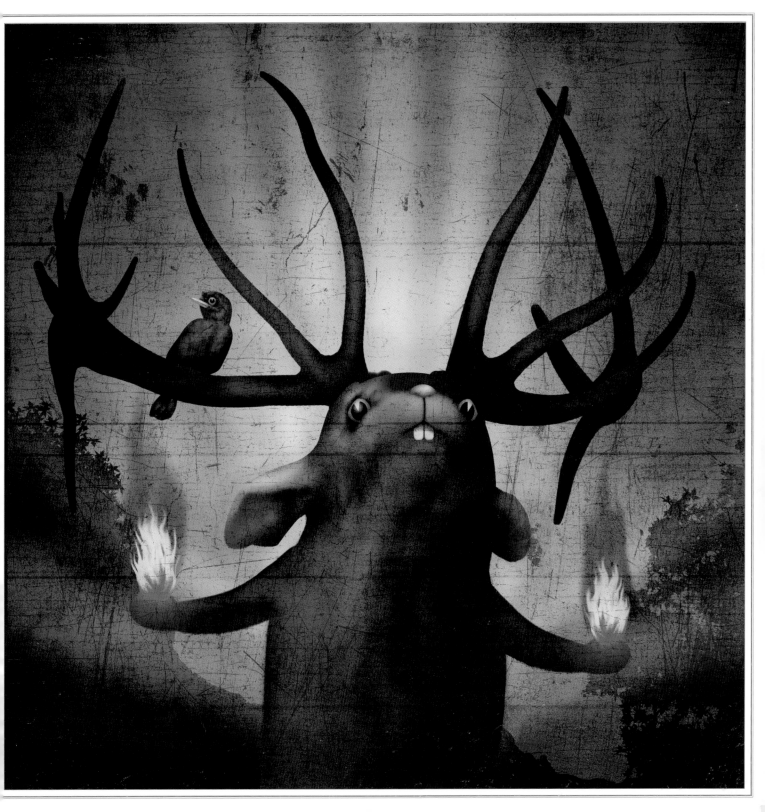

# Yara-ma-yha-who

Relatively small and altogether toothless, this seemingly unimpressive red-faced demon has to rely on stealth to catch its prey. **YARA-MA-YHA-WHO** is an Australian vampire, reputedly quite nasty, that makes its home in fig trees. Its fingers and toes, curiously tipped with octopus-like suckers, help it cling to treetop branches—and later, to its prey. When an unsuspecting child passes underneath the fig tree, the demon flings itself on top of it, sucks its blood, and, having a suitably enormous mouth, swallows the child whole. After a nap (the process of eating children being, apparently, exhausting), the **YARA-MA-YHA-WHO** regurgitates the child, who reappears alive and unharmed but several inches shorter. Keeping with vampiric tradition, a child caught repeatedly will eventually become a **YARA-MA-YHA-WHO**.

Opposite: Plate 91 . MICHAEL SLACK

# Aunyaina

An enormous cannibal humanoid of the South American rainforests, **AUNYAINÁ** was known to have survived on a diet of wandering youth, which he hunted and gored with his boarlike tusks. Certain reports claim that one day when the mammoth beast was hunting a group of children, they scrambled up some vines to take refuge in the forest canopies. They escaped to safety and lived out their days as the monkeys of the forest, but **AUNYAINÁ** was not so lucky. As **AUNYAINÁ** lay dead on the ground, his body gave rise to the serpents and lizards that populate the Earth to this day.

Following: Plate 92 . SOUTHER SALAZAR

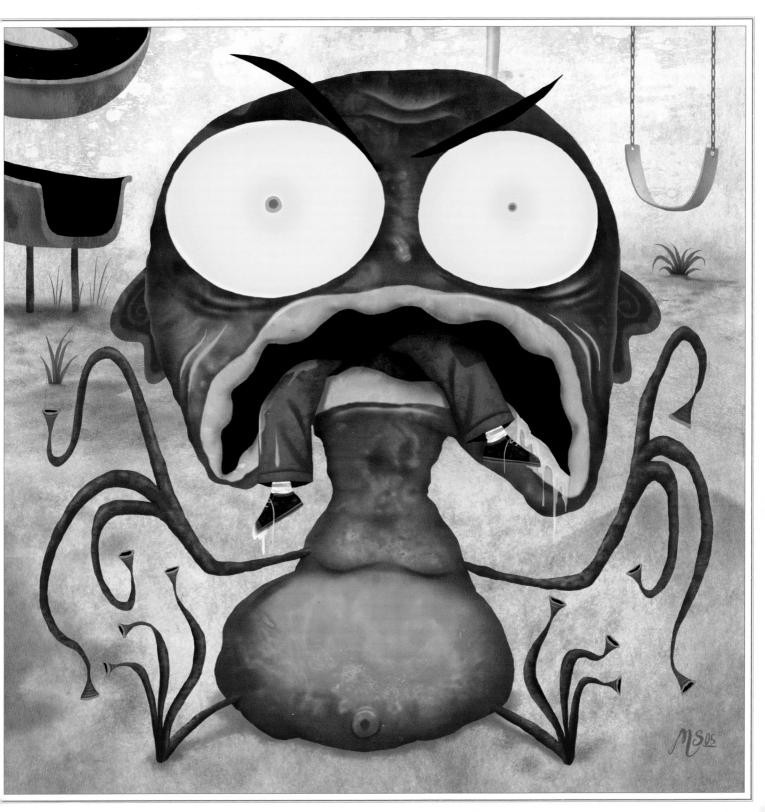

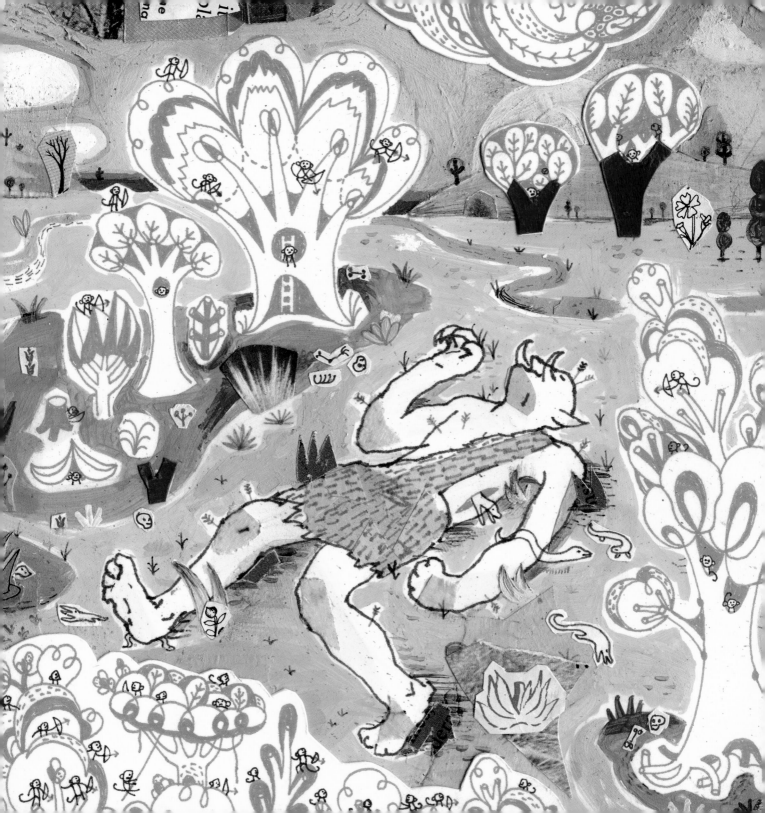

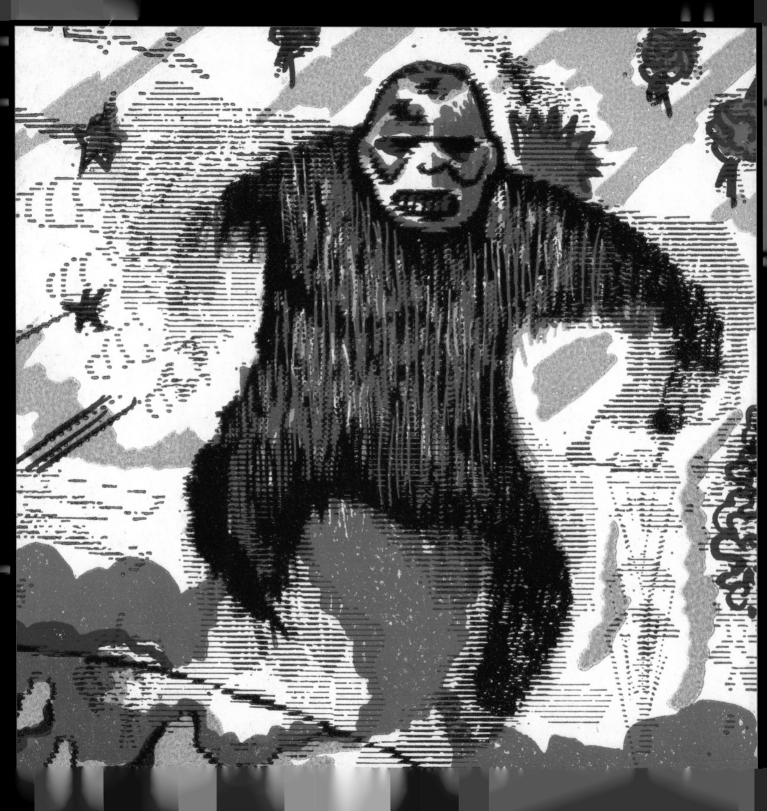

Daniel Taylor, INTERVIEW WITH A YETI HUNTER. *What really got a hold of me was that the Yeti wasn't just a ghost, because there were footprints. And that distinguishes it from other beasts, other legends, because there's something that's making those mysterious footprints.*

DANIEL TAYLOR's grandparents moved to India as medical missionaries, and he is part of the third generation of Taylors to experience life in the Himalayas. Taylor's fascination with the Yeti, a legendary manlike giant, began in 1956 when he saw a picture of the alleged Abominable Snowman's footprint on the front page of the newspaper THE STATESMAN. This childhood curiosity grew into a quest to unearth the mystery of the Yeti, and, as he became convinced there is a scientific explanation to that, more recently into a passion to protect and preserve the wilderness area the Yeti calls home. Today, he is president of the nonprofit organization Future Generations. For his work in Himalayan conservation

Taylor was decorated by His Highness Prince Bernhard of the Netherlands with the Order of the Golden Ark, and his unique approach to conservation also earned him a knightship from the King of Nepal and the first honorary professorship of ecology from the Chinese Academy of Sciences. His book SOMETHING HIDDEN BEHIND THE RANGES: A HIMALAYAN QUEST (Mercury House, 1995) is Taylor's account of his lifelong love of nature, his search for the Yeti, and how these two passions converge. He currently lives in West Virginia.

INTERVIEW *by* Felicia Gotthelf

GOTTHELF: *What place do you think the Yeti holds in cultural mythology? Why is the Yeti so fascinating to people around the world?*

TAYLOR: The Yeti comes out of Nepali culture. Sherpa culture, really. The Sherpas are an ethnic group within Nepal, and that's its home. I've talked to Sherpas and tried to separate out the current mythology of the Yeti. Because it's been so picked up and focused on by Westerners, it's become a much larger mystery now than it was in purely Sherpa culture. In the ancient Sherpa

understanding there are many aspects of their Tantric Buddhist religion that the Yeti plays to. It's the ability to move through reality, physical reality, so that you'd have things like Shangri La, and you have the movement of spirits in the land, and the animistic religions, and you have the ability of different levels of mind consciousness, and these sorts of things. So, the Yeti can be a very real animal, a very real living being, and also a very real spiritual being. It's a much more profound understanding than what those of us in the West grow up with,

with bogeymen in the night, because the Nepali cultural framework gives them that type of understanding.

*So the stories about the Yeti may be different in different cultures?*

The first Yeti sighting by Westerners was in 1898, and then of course there is the sighting in 1921 of the Abominable Snowman (which is a mistranslation of a Tibetan word) by one of the first British expeditions. When the Yeti story really starts to get embellished is in the

1960s and '70s, when it becomes very much more of a real beast, and people like Edmund Hillary go out Yeti-searching, as he did from 1961 to '62. So at that point, looking for the wild hominoid, the cultural aspect moves from what we'd call myth or myth-spirit-transcendental into possible science. And so people now have been saying that the Yeti exists or it does not exist as a wild hominoid. Well, that's a very different question from this mythic figure of the Sherpa culture. So the cultural context you're looking in, whether it's science or mythology, is very important.

*Did your upbringing contribute to your fascination with the Yeti?*

I come from a family that had been hunting in the Himalayan jungles for, well, I'm the third generation. I became interested in the Yeti in 1956 when I was ten years old, and I saw on the front page of a newspaper the famous Shipton footprint, that archetypical piece of evidence [for the existence of the Yeti]. We were living and going to school at 6,000 feet at the time, and a museum curator in Britain had said the footprint was made by a langur monkey in the snow on a glacier in Nepal. I knew that a langur monkey did not make that footprint because we had them all around our house. And I just got to thinking, "What an interesting mystery." I found the idea of the beast

captivating, just as it is to many people. And so then I just started probing around the house looking for the Yeti. You know, it was a childhood game and my mother sort of patted me on the head.

*Do you remember what it was about the Yeti that captured your imagination as a child?*

What really got a hold of me was that the Yeti wasn't just a ghost, because there were footprints. And that distinguishes it from other beasts, other legends, because there's something that's making those mysterious footprints. That is really the inescapable point. For years I wondered what was making those footprints in the snow. Then I realized the obvious, that there were no Yeti stories around the part of the Himalayas where I was. In fact, there were no Yeti stories in any of the Indian Himalayas. There have since been Yeti stories from the Indian Himalayas—they are popular things for people to talk about—but in the '50s there weren't. So then in the '60s I started to go to Nepal, and I worked in Nepal, and I had access to a helicopter. I was able to go to a lot of the sites and start looking at where other footprints were found. And the pieces started to come together.

*How did the pieces start to come together?*

When I was a graduate student at Harvard, I became close friends with

the then Crown Prince of Nepal, then later, king. He was giving me ideas and information based on royal intelligence information. The long and the short of it is that I became convinced that the best place to search for the Yeti was very close to where Shipton had actually found his prints, and where Cronin and McNeely found others. I mapped out where all the stories were coming from. And it was one particular valley there, called the Barun Valley, that ultimately became a national park because we found Yeti footprints there ourselves. And at that point it becomes clear that it's a bear, and at first we think it's maybe a new species of bear, but ultimately we believe that it is a juvenile of a well-known species of bear, an Asiatic black bear.

*How did you reach the conclusion that the footprints were made by a bear?*

I can now show very clearly that the Shipton print is an overprint of a hind foot footprint on top of a forefoot footprint of this bear. That's why you only have these footprints going uphill. I mean, just look at the straight science of it. A bear is like the housecat that you have back home in your apartment. Every time it walks around it puts its hind paw exactly where its forepaw was. But if you take a housecat and let it scamper up a hill with a light dusting of snow on it, you will see that its hind paw no longer falls exactly where its forepaw is—it falls a little backwards. So that

four-footed animal starts to look like a two-footed animal, because it's putting its hind paw where its forepaw is. There's a little bit off print, so it's not a pure overprint, it becomes elongated because it's falling back a little bit. Then it starts to look hominoid instead of round like a bear paw. These overprints become striking when made by juvenile bears—for a young bear's foot, especially when it does a lot of tree-climbing, has its inner digit pushed sideways so it looks like a hominoid thumb. The overprint feature plus the thumblike digit certainly does not look bearlike, but it is.

*Have you tested out your theory? Can you prove that a black bear made the footprints?*

I've trapped and tranquilized the bear, and I can replicate with a tranquilized bear every Yeti footprint that's ever been taken by putting its feet down in plaster. So I'm looking for somebody to bring me some evidence that I can't replicate with a bear. About every six months I get a Yeti video or something, maybe from some studio in Hollywood, that, when I show it a couple times, I see that it's a person in a monkey or gorilla suit—or maybe just a Yeti-shaped rock in the snow. That's always a lot of fun. I sit down with my kids and put that cassette in and say, "Okay, where's the zipper on the suit?"

*Do you think that your scientific evidence will have an impact on the Yeti's place in cultural mythology? Will people stop being interested in the Yeti if it turns out to be a black bear?*

The myth of the Yeti never lets go. It just haunts people. I don't really ever explode the myth in my book, because the book publisher thought it would be better to preserve the myth. So while I say in the text that it isn't a Yeti that leaves footprints, I pointedly leave a huge question mark because I just thought it would be a more hypnotic story. Saying, well maybe it's still out there. It's a story that's larger than life, obviously, and for which science is only part of the answer. And it appeals to basic, primal aspects of where we've come from and what our issues are.

*How has your obsession with the Yeti changed, now that you are fairly sure the Yeti is a black bear?*

My interest goes on to preserving a habitat and getting involved with starting a national park. We'll be doing an article for NATIONAL GEOGRAPHIC on a nature preserve that's the size of Washington State and that probably has the best habitat on the planet for protecting this particular bear. It's called the Four Great Rivers Nature Preserve. There is a huge national park on the Nepal side and now one adjacent to it around Mt. Everest on the Tibetan side. I've just returned also from fieldwork with a couple major nature preserves in the Indian Himalayas between Bhutan and Burma—and found reports of Yetis. I'm pretty sure

what it really is—an animal that is doing strange things—but what's important is that people are enjoying this. But with more and more wild habitat protected, the Yeti will forever have its home and be able to roam. That's my personal contribution, a way to keep the Yeti alive by giving wild habitat for the mystery to flourish, rather than continuing to go stand up and try to lecture and explain the Yeti.

*Habitat preservation seems like a wonderful way to reconcile the mystery of the Yeti with the reality of the Yeti.*

I started out as a ten-year-old boy convinced the Yeti exists. And I still, as a 62-year-old dinosaur, would like it to exist. My hope now, what I'm trying to do, is to preserve these wonderful wild valleys, so people can go off there and continue to believe in the Yeti as I do. I go walking now and I go around corners and I say, well, maybe this time I will step around the corner and I will see the Yeti. Even now, although I am a hundred percent convinced that the Yeti is the Asiatic black bear, I still obviously hope. I no longer carry a little bit of plaster of Paris in a bottle so I can make a Yeti imprint (which I did for decades) when I'd find its footprint. I've moved away from that level. But I have my camera ready just in case. 🐾

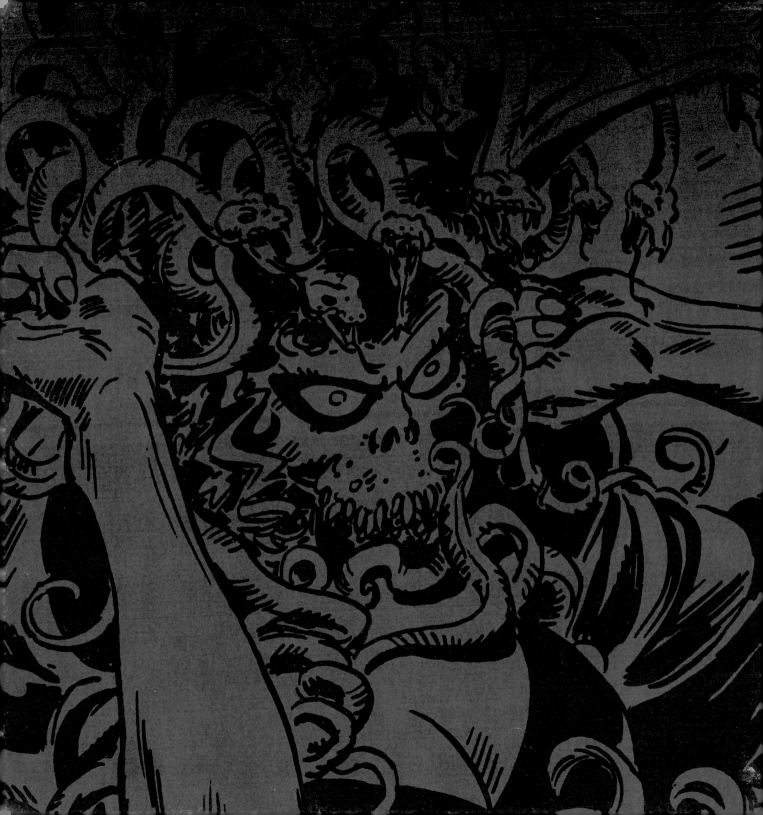

# LIST of CREDENTIALS.

**Attaboy**, sometimes known as Daniel Seifert, embraces the sun-faded plastic sunken cruise ship of happiness. Attaboy's work appears internationally in galleries, molded into vinyl effigies with interchangeable mouths, and most recently, on television. www.yumfactory.com [Pl.63, Melusine]

**Marc Bell** lives in Vancouver, BC, where he makes things. His work has appeared in *Kramer's Ergot* and in the *New York Times*. He also edited *Nog a Dod: Prehistoric Canadian Psychedoolia* for Conundrum Press/Picture Box (2006). www.adambaumgoldgallery.com [Pl.47, Golem]

**Tim Biskup** is a southern California fine artist whose work has been shown worldwide in galleries and museums from Los Angeles to Melbourne. He has collaborated with artists and designers and organized art auctions and exhibitions. His original work reflects a fondness for mid-century modern design and illustration. www.timbiskup.com [Pl.05, Amermait]

**Andrew Brandou** is an illustrator and fine artist living in Los Angeles, CA. His work can be seen on television, in print, and in galleries across the country. In 2006 he had his first solo show in New York. He can be seen hanging out with his cat, Chloe. www.howdypardner.com [Pl.23, Big Ears]

Texas-born **Mat Brinkman** attended a special high school for the arts before entering the Rhode Island School of Design. His comics contain monsters and other fantasy-tinged creatures exploring elaborately constructed, roughly textured environments. www.fortthunder.org [Pl.35, Chenoo]

Originally from Louisiana, **S.britt** currently resides in northern California with his morbidly obese cat, Edsel. A beginning doodler and reluctant learner, he thrives on a steady diet of lead-based paint chips and aspires to be a fire truck when he grows up. www.sbritt.com [Pl.81, Troll]

**Scott Campbell** is a regular contributor to the comic anthology *Hickee*. He has also appeared in collections such as *Project: Superior* and *SPX 2005*. He is the art director and a cartoonist for Double Fine Productions where he helped make the video game Psychonauts. www.scott-c.blogspot.com [Pl.36, Cliff Ogre]

**Martin Cendreda** is a cartoonist from Los Angeles. He still retains a healthy fear of the supernatural, borne of childhood afternoons steeped in *Movie Macabre*, the *Twilight Zone*, and the Time Life book series: *Mysteries of the Unexplained*. www.zurikrobot.com [Pl.15, Aswang]

Seattle designer **Art Chantry** has won hundreds of design and advertising awards, including a bronze lion at Cannes. His work has been collected and exhibited by the Louvre, the Smithsonian, the Library of Congress, and the Rock and Roll Hall of Fame. In 2001, Chronicle Books published the monograph of his work, *Some People Can't Surf*. www.artchantry.com [Pl.03, American Buffalo]

**Don Clark** was cofounder and a principal art director of the now defunct Asterik Studio. He has contributed to many books, designed music packages, and his work has been featured in various publications such as *Print*, *Communication Arts*, and *HOW*. He also cofounded Seattle's Invisible Creature design studio. www.invisiblecreature.com [Pl.41, Dog-Faced Bunyip]

As art director and lead print designer for Tooth & Nail Records in Seattle, as well as the design studio Invisible Creature, **Ryan Clark**, like his brother Don Clark above, has been featured in many prestigious publications. In 2005 he received a Grammy nomination for package design. www.invisiblecreature.com [Pl.07, Aeternae]

**Josh Cochran** draws regularly for national publications that include the New Yorker, *Outside* magazine, and the *New York Times*. This is the first time he has ever been asked to draw a merman. www.joshcochran.net [Pl.80, Triton]

**Dave Cooper** made his name in comics and animation, but has since more or less focused on oil painting and drawing. He has had solo gallery shows in Paris, Los Angeles, New York—and, in 2007, Rome. He lives in Canada with his wife and three-year-old son. www.davegraphics.com [Pl.37, Bapets]

**Colleen Coover**'s comic books include the erotic *Small Favors*, and for younger readers, *Banana Sunday*, written by Root Nibot. Coover is working with writer Paul Tobin on a graphic novel called *Freckled Face, Bony Knees, and Other Things Known About Annah*. She lives in Portland, OR. www.cooverart.com [Pl.17, Baba Yaga]

**Kevin Cornell** is a designer and illustrator from Philadelphia, PA. He is afraid of monsters, and will probably not be able to read this book. www.bearskinrug.co.uk [Pl.42, Donestre]

**Jacob Covey** lives in a house in Seattle with his wife Liz. www.unflown.blogspot.com [Pl.11, Argus]

**Jordan Crane** lives in Los Angeles. www.reddingk.com [Pl.56, Laestrygonians]

**Kevin Dart** is an illustrator in the Seattle area, originally from south Texas. He is influenced by the masters of pulp such as Robert McGinnis and Frank Frazetta. www.kevindart.com [Pl.69, Odontotyrannus]

**Ray Fenwick** is an illustrator, artist, and letterer living in Halifax, Nova Scotia. www.coandco.ca/ray [Endpapers]

**PJ Fidler** is a painter and motion graphics designer living and working in Los Angeles. His work has been shown in many different countries and all over the U.S. He lives with his wife, Debi, his two dogs, Dita and Kai, and his cat, Mali. www.pjfidler.com [Pl.29, Cacus]

**Jeremy Fish** is one of the most respected illustrators in skateboarding. His work has been featured in exhibits around the world and is collected in the book *I'm With Stupid* from Upper Playground. www.sillypinkbunnies.com [Pl.54, Kraken]

**Renee French** has been making comics since the early '90s. Her new books are *The Ticking* and *My Best Sweet Potato*, her second children's picture book written under the name Rainy Dohaney. She lives and works in the U.S. and Australia with her husband, Rob, and some red shrimp. www.reneefrench.com [Pl.24, Bigfoot]

**Tom Gauld** grew up in Scotland and now lives in London with his partner, Jo, and daughter, Daphne. He makes illustrations and comics, and particularly likes to draw monsters and robots. www.cabanonpress.com [Pl.89, Wizard's Shackle]

**Charles Glaubitz** lives and works in Tijuana, where he teaches illustration. He has exhibited his work in Los Angeles, New York, Madrid, Zaragosa, San Diego, Tijuana, and Mexico City. www.mrglaubitz.com [Pl.08, Ahuizotl]

**Kaela Graham** is inspired by poof wiggles because they are inspired by boots, celery, sweaters, bug bites, funny words, green beans, Ballard, paranoia, boofs, peanut butter, burrowing, and the snug. www.kaelagraham.com [Pl.20, Barometz]

**Adam Grano** grew up on the Oregon coast amidst the fir trees and lumberjacks. He now lives in Seattle where he enjoys drawing and graphic design and sewing and video games and cats and some other stuff too. www.adamgrano.com [Pl.28, Brownies]

**Dan Grzeca** is a painter and printmaker. He is fixated on drawing figures with feet made of bird and dog heads. He draws and designs a fair number of screenprinted music posters. He resides in Chicago with his wife, Kristen, and daughter, Ella Kane. www.grzeca.com [Pl.48, Gorgon]

**Sammy Harkham** is the editor of and contributing cartoonist for Kramer's Ergot. He also draws the ongoing comic book *Crickets*. www.kramersergot.com [Pl.84, Utukku]

**Gilbert Hernandez** created *Love & Rockets* in 1981, along with his brothers Jaime and Mario. Twenty-five years later, the series remains one of the most influential comic books of its generation. Hernandez lives in Las Vegas, NV, with his wife and daughter. www.fantagraphics.com [Pl.02, Sea Hog]

**Mike Hoffman**, once called "The Most Outspoken Man in Comics" (Creem Magazine), has been known to receive death threats for his regular savagings of the status quo. "Any artist not actively in revolt against the present is a mere merchant," he says. www.mikehoffman.com [Pl.34, Cheeroonear]

**Maxwell Loren Holyoke-Hirsch**'s almost melancholic comic portrayal brings humility to one and all. There is humanity here to see. A geometry of endearing memories and there is relief, the influence and impact of time. www.lorenholyoke.com [Pl.59, Loch Ness Monster]

**Seonna Hong** balances art, animation, and raising a family with her husband, fellow artist Tim Biskup. In 2004 she was recognized with an Emmy award for her work on *My Life as a Teenage Robot* and continues to keep her plate full with gallery shows. Her first book, *Animus*, was published in 2005. www.seonnahong.com [Pl.83, Unicorn]

**Katy Horan** lives in Brooklyn, making art inspired by folktales and old-timey music. When not making a big mess in her studio, she likes to drink herbal tea and have epic bike adventures. www.katyart.com [Pl.18, Banshee]

**Nathan Huang** is the quintessential comic geek turned "artist." His lack of social, athletic, and mathematical skills forced him to turn an unhealthy obsession with doodling into a career. He really is a nice guy once you get to know him. You just have to get past his personality. www.nathanhuang.com [Pl.68, Nuckalevee]

**Meg Hunt** draws funny little pictures for fun and profit. She lives under a rock somewhere in the desert and is obsessed with seeking out the weird and new. www.meghunt.com [Pl.45, Erinyes]

**Stella Im Hultberg** is an artist living in New York City. When she is not drawing or painting, she likes to search for the perfect cupcake. www.stellaimhultberg.com [Pl.82, Tui Delai Gau]

**Jason** was born in Norway in 1965. He currently resides in Montpellier, France. www.mjaumjau.net [Pl.66, Minotaur]

**James Jean** awakes each day drained of life's vigor and clouded with shame. A lemon levitra shooter braces him for the night terrors ahead. He lives and works in Santa Monica, CA. www.jamesjean.com [Pl.76, Succubus]

**Foi Jimenez Jurado** lives in Tijuana with her daughters, Luna and Love, and her husband, Charles Glaubitz. She loves to teach design and illustration and likes to read about the invisible forces of the universe. www.foijimenezjurado.com [Pl.75, Sphinx]

**Brenthalomew Alan Johnson** was born on a freezing Minnesota evening, silently raised in Wisconsin, and after residing in other areas of the globe, lives in New York City. He wishes to retire to a wooded grove to paint, spend late nights in a woodshop, and sketch on a used pad of paper in a sleepy morning coffee shop. brenthalomew@hotmail.com [Pl.16, Auvekoejak]

**R. Kikuo Johnson**'s comics and drawings have appeared in the *New York Times*, the *New Yorker*, and *The Believer*.

His debut graphic novel, *Night Fisher*, was released in fall 2006 from Fantagraphics. He cartoons from a former sweatshop in postindustrial Brooklyn. www.seabread.com [Pl.13, Asp Turtle]

**Ted Jouflas** is an occasional illustrator whose work has appeared worldwide in various newspapers and magazines including *Rolling Stone*, *Spin*, *RayGun*, and *American Illustration* (seven times). In 2002 Jouflas was honored with the top prize for illustration from AIGA. www.fantagraphics.com [Pl.74, Siren]

**Nathan Jurevicius** is an Australian artist living in Toronto, Canada, with his wife, Lizzy, three kids (Milo, Arkie, and Sass), and one imaginary friend. His most acclaimed project to date is his Scarygirl brand of toys, comics, and designer products. www.nathanj.com.au [Pl.43, Drac]

**Andy Kehoe** lives and works in Pittsburgh, PA. One day, he helped a child get his kite out of a tree and almost killed himself. He now lives in constant fear of children and flying toys. www.andykehoe.com [Pl.62, Manticore]

Seattle-born and San Francisco–roosting, **Angela Kongelbak** spends her time beautifying the world one corporation at a time, all the while pursuing her quixotic quest to cut back on robot spending. www.kongelbak.com [Pl.31, Catoblepas]

Inspired by ideograms, syllables, letterforms, beasts, and heroic landscapes, **Ronald Kurniawan** continues to create a visual language where wilderness and civilization could merge happily together. He lives and works in the quiet town of Los Angeles. www.ronaldkurniawan.com [Pl.10, Albastor]

**Kenneth Lavallee** lives and was conceived in Winnipeg, Canada, where he now attends fine arts classes at the University of Manitoba. In his spare time he enjoys playing with out-of-production video game systems, eating Fig Newtons, and writing in the third person. www.knnth.com [Pl.27, Boraro]

**Jesse LeDoux** gave up his career as an art director at Sub Pop Records to focus on his illustration work. A Grammy nominee, LeDoux works out of his studio in Providence, RI, where he combines his avant-garde design sensibility with the basics: pens, pencils, and a few sheets of paper. www.ledouxville.com [Pl.21, Bautatsch-Ah-Ilgs]

**The Little Friends of Printmaking** started out as a laugh but pretty soon turned into a farce. They made a name for themselves through silkscreened concert posters, the inviting surfaces of their screenprinted work, and an aesthetic that sets the hearts of material-culture-junkies a-twitter. www.thelittlefriendsofprintmaking.com [Pl.50, Hundred-Handed Giant]

**Corey Lunn** was born and raised in New York State. He currently lives in Portland, OR, where he is employed as a

sign painter, artist, and illustrator. He enjoys a girlfriend, a cat, and slightly more than the national mean of five close friends. www.urbanhonking.com/pictureswamp [Pl.38, Cyclopedes]

**Jessica Lynch** (a.k.a. Slow Loris) is an island dweller living and working on Guemes, a short ferry ride from nowhere in particular. Often one might find her in a rundown barn bent over a six-color press singing and squeezing ink onto shirts whilst a print monkeyfriend runs them through the drier. www.slowshirts.com [Pl.67, Monoceros]

**Alex Meyer** lives in Colorado and sells paintings in galleries in California. He is mildly amused. www.alexjmeyer.com [Pl.40, Disembloweller]

I must leave and go to school. The whales have come; the children are hungry. I mean ugly scars from deserved (meat) torment. You require disfigurement. And toothache. Gangrene. "I don't know how I lived before you helped me develop this new organ." Wyoming, 1979. (**Jason Miles**) www.horswhistle.blogspot.com [Pl.78, Thunderbird & Uncegila]

**Tony Millionaire**'s grandparents taught him to love and draw comics in the seaside town of Gloucester, MA. He has won Eisner and Harvey Awards, including Best Syndicated Strip in 2004 (for *Maakies*). He now lives in Pasadena, CA, with his wife and two daughters. www.maakies.com [Pl.79, Leviathan]

**Alan Mooers** lives in Bellingham, WA. When he was young, he drew many pictures of the Space Needle. Though his doctoral studies focused on drawing cakes, Mooers now enjoys spending his free time drawing buses. alanmooers@yahoo.com [Pl.72, Puk]

**Heiko Müller** studied illustration and design at the Hamburg University of Applied Sciences. Outside his native Germany his paintings and drawings have been shown in Estonia, New York, Paris, St. Petersburg, Sacramento, and San Diego. His work sometimes explores the borderlines between rural folk art, B-movie aesthetics, and the Flemish masters. www.heikomuller.de [Pl.90, Wolpertinger]

**Julie Murphy** lives and works in Chicago. An assortment of monsters lives in her head. www.juliemurphy.info [Pl.14, Aspis]

**Chris Silas Neal** is an artist and illustrator whose work has been recognized by *Communication Arts*, *American Illustration*, the Society of Illustrators, and *Print* magazine. He works and lives in Brooklyn. www.redsilas.com [Pl.87, Werewolf]

**Anders Nilsen** is the Chicago-based artist and author of *Big Questions*, *Dogs and Water*, and *Monologues for the Coming Plague*. His work has also appeared in *Kramer's Ergot* and *MOME*. www.theholyconsumption.com [Pl.73, Sianach]

# LIST of CREDENTIALS.

**Martin Ontiveros** grew up in San Diego, CA, until it drove him crazy enough to move away and go to art school. Now he ekes out a living in Portland, OR, drawing stuff that kids doodle in their notebooks when they are bored in history class. www.martinhead.com [Pl.60, Long Wang]

**Brian Ralph** created the graphic novel, *Cave-In*, and won a Xeric grant for his second book, *Climbing Out*. He is also a "professor" of "sequential art" at the Maryland Institute College of Art in Baltimore. www.reggie12.com [Pl.30, Carn Galver]

**Ron Regé, Jr.**'s early book *Skibber Bee-Bye* was recently republished by Drawn & Quarterly, along with the thirteenth installment of his *Yeast Hoist* series. He currently lives in Los Angeles where he plays drums in the band Lavender Diamond. www.lavenderdiamond.com [Pl.44, Draug]

**Jesse Reno** is a self-taught mixed-media painter. He has amassed a portfolio of more than 700 paintings and his work can be seen on skateboards, walls, and book covers, as well as in contemporary art books and galleries. www.jessereno.com [Pl.70, Pegasus]

**Lesley Reppeteaux** is down with the darker side of whimsy. Pouty-lipped creatures with melancholy beauty permeate her work to create a peculiar world filled with chimera and charm. www.reppeteaux.com [Pl.25, Black Annis]

**Eric Reynolds** is a part-time cartoonist and full-time comic-book pimp who lives in Seattle. www.comicartcollective.com/reynolds [Pl.26, Boa]

**Jason Robards** is an illustrator and printmaker from St. Louis, MO, where he lives with his wife and their dogs, working on projects and attempting to reintroduce the world to the Kid 'n Play Kick Step. www.itscoolsteve.com [Pl.06, Acephalite]

**Jay Ryan** draws and screenprints posters at the Bird Machine in Chicago, and plays bass guitar in a band called Dianogah. Ryan is only able to continue due to the encouragement of his wife, Diana Sudyka, and their greyhound, Seth. www.thebirdmachine.com [Pl.77, Thunderbeast]

**Johnny Ryan** draws *Angry Youth Comix*, *Blecky Yuckerella*, and the *Comic Book Holocaust*. He lives in Los Angeles with his wife. www.johnnyr.com [Pl.49, Harpy]

**Chris Ryniak** started life as a baby. He is now a painter and sculptor of monsters and more worldly creatures as well. Flanked by his two kids and overly supportive wife, Ryniak lives in suburban Cleveland, OH, where he brings more oddness into the world on a daily basis. www.bigistudio.com [Pl.61, Lou Carcolh]

**Stan Sakai** was born in Kyoto, Japan, grew up in Hawaii, and now lives in southern California. His award-winning series, *Usagi Yojimbo*, is the story of a samurai rabbit living in a feudal Japan populated by anthropomorphic animals. His books have been translated into eleven languages. www.usagiyojimbo.com [Pl.46, Gaki]

Books by **Richard Sala** include *Mad Night*, *Peculia*, *The Chuckling Whatsit*, *Maniac Killer Strikes Again!*, and *The Grave Robber's Daughter*. His serial *Delphine* is published simultaneously in Europe and the U.S. He has illustrated work by many authors, ranging from Jack Kerouac to Lemony Snicket. He resides in northern California. www.richardsala.com [Pl.86, Vodnik]

**Souther Salazar** is a funny monkey who draws funny little monkey pictures. www.southersalazar.net [Pl.92, Aunyainá]

**Kevin Scalzo** was born in Winnipeg, Canada, but left shortly after (too cold). He is known for his sweaty, cute, and creepy pop imagery, and he continues to push the boundaries of what's bizarre and sweaty in the worlds of painting and comics art. www.kevinscalzo.com [Pl.51, Kabandha]

**Keith Andrew Shore** is a Pennsylvania artist, a drawer and painter of gorilla swordsmen and humans with sharp teeth. www.kasprojects.com [Pl.32, Centaur]

**Michael Slack**'s character-driven, humorous art can be seen in magazines and gallery exhibitions in the U.S. and Europe. He recently finished his first picture book for Harcourt, and is working on his monster card game *Ick!* and a picture book for Chronicle Books. www.slackart.com [Pl.91, Yara-Ma-Yha-Who]

As a youngster **Jeff Soto** spent many hours in the public library reading about Bigfoot, UFOs, and ghosts. Still a believer in and dreamer of the unknown, Soto lives and works in Riverside, CA, with his wife and daughter. His work has been shown in galleries internationally and collected in the book, *Potato Stamp Dreams*. www.jeffsoto.com [Pl.65, Minata-Karaia]

**Bwana Spoons** was born and raised by Kappa in the gentle pools of Horseshoe Falls. www.grasshutcorp.com [Pl.52, Kappa]

Growing up in Brush Prairie, WA, **Tyler Stout** had two terriers (ran away/hit by car), one wolfhound (catkiller, put to sleep), one yellow lab (hit by car, shot by father), one German shepherd (crazy, shot by father), one black lab (SBF), one poodle (car), and forty cats (deceased). www.tstout.com [Pl.55, Kukuweaq]

**Deth P. Sun** received his BFA in painting and drawing from the California College of Arts and Crafts in 2002. He resides in Oakland, CA, and his work has been shown throughout the U.S. www.dethpsun.com [Pl.12, Aries]

**Scott Teplin** is an artist living in Brooklyn whose work is shown in the Museum of Modern Art (SF and NY), the New York Public Library, the Smithsonian, the Walker Art Center, the Brooklyn Museum of Art, and the New Museum of Contemporary Art. www.teplin.com [Pl.58, Loathly Worm]

**Peter Thompson** has shown his art in New York City and also in Sackville, New Brunswick. He has more than fifty photocopied "art book" titles, most of which are no longer available. www.beguiling.com [Pl.57, Leveller]

The only son of two talented artists, **Joe Vaux** learned the joys of creation at an early age. He has been honing his skills for the past twenty years, first receiving a BFA from New York's Syracuse University and then working with the folks of the animation world. www.joevaux.com [Pl.88, Wihwin]

**Amanda Visell** is a monster. She loves cheese and pretzels. She is afraid of roller coasters and diving. In her spare time she volunteers by reaching high things for short people, and low things for tall people. www.thegirlsproductions.com [Pl.33, Cerberus]

A lover of horror comics from her childhood, **Mizna Wada** was born in Kumamoto, Japan. She resides in Tokyo. www.hihou.net/mizna [Pl.53, *Kojiki*'s Yamato no Orochi]

**Esther Pearl Watson** grew up in the Dallas-Fort Worth area in Texas. Watson's pieces are often overtly narrative, clear but mysterious scenes of houses or figures ornamented with snippets of prose. Her works have been commissioned by magazines including *Time*, the *New York Times*, and *Entertainment Weekly*. www.estherwatson.com [Pl.09, Aitvaras]

Born in Alaska, **Sam Weber** grew up in Canada, and currently lives in Brooklyn. www.sampaints.com [Pl.85, Vampire]

**Steven Weissman** has long been regarded as "America's Favorite Cartoonist." He has published five books with Fantagraphics, and if you don't have all five of them then you're really only cheating yourself. www.sweetchubby.blogspot.com [Pl.71, Pey]

**Justin B. Williams** grew up in Asia and now lives in Chicago. He would like to be as good at drawing as he is at wandering about. justinobwilliams@yahoo.com [Pl.64, Mimic Dog]

**Nate Williams** (a.k.a. n8w) is originally from the western U.S. He has lived and traveled in South and Central America while freelancing as an illustrator. www.n8w.com [Pl.39, Cyclops]

**Dean Yeagle** has an animation company (Caged Beagle Productions), illustrates children's books, and draws gag cartoons for *Playboy* magazine. He has published his own sketchbooks and is working on a comic book for Dark Horse and Disney. www.cagedbeagle.com [Pl.19, Barguest]

# TAXONOMICAL DIAGRAM.

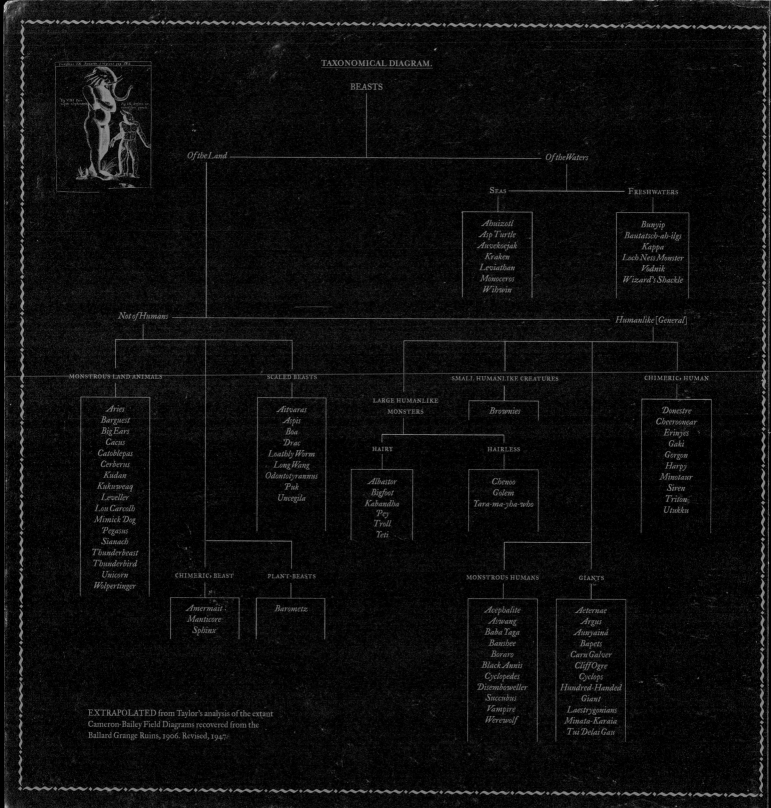

BEASTS

Of the Land — Of the Waters

Seas — Freshwaters

**Seas**
- Ahuizotl
- Asp Turtle
- Auvekoejak
- Kraken
- Leviathan
- Monoceros
- Wihwin

**Freshwaters**
- Bunyip
- Bautatsch-ah-ilgs
- Kappa
- Loch Ness Monster
- Vodnik
- Wizard's Shackle

Not of Humans — Humanlike [General]

**MONSTROUS LAND ANIMALS**
- Aries
- Barguest
- Big Ears
- Cacus
- Catoblepas
- Cerberus
- Kudan
- Kukuweaq
- Leveller
- Lou Carcolh
- Mimick Dog
- Pegasus
- Sianach
- Thunderbeast
- Thunderbird
- Unicorn
- Wolpertinger

**SCALED BEASTS**
- Aitvaras
- Aspis
- Boa
- Drac
- Loathly Worm
- Long Wang
- Odontotyrannus
- Piuk
- Uncegila

**CHIMERIC, BEAST**
- Amermait
- Manticore
- Sphinx

**PLANT-BEASTS**
- Barometz

**SMALL HUMANLIKE CREATURES**

**LARGE HUMANLIKE MONSTERS**

**HAIRY**
- Albastor
- Bigfoot
- Kabandha
- Pey
- Troll
- Teti

**HAIRLESS**
- Chenoo
- Golem
- Tara-ma-yha-who

**Brownies**

**MONSTROUS HUMANS**
- Acephalite
- Aswang
- Baba Yaga
- Banshee
- Boraro
- Black Annis
- Cyclopedes
- Disembolweller
- Succubus
- Vampire
- Werewolf

**GIANTS**
- Aeternae
- Argus
- Aunyainá
- Bapets
- Carn Galver
- Cliff Ogre
- Cyclops
- Hundred-Handed Giant
- Laestrygonians
- Minata-Karaia
- Tui Delai Gau

**CHIMERIC, HUMAN**
- Donestre
- Cheeroonear
- Erinyes
- Gaki
- Gorgon
- Harpy
- Minotaur
- Siren
- Triton
- Utukku

EXTRAPOLATED from Taylor's analysis of the extant
Cameron-Bailey Field Diagrams recovered from the
Ballard Grange Ruins, 1906. Revised, 1947.

# SELECT BIBLIOGRAPHY.

## BOOKS.

Aeschylus. THE ORESTEIA. Translated by Robert Fagles. Middlesex, England: Penguin Books Ltd., 1975.

Andersen, Hans Christian. HANS CHRISTIAN ANDERSEN FAIRY TALES. Translated by Tiina Nunnally. Penguin, 2004.

Borges, Jorge Luis. THE BOOK OF IMAGINARY BEINGS. E.P. Dutton & Co., 1969.

Bulfinch, Thomas. BULFINCH'S MYTHOLOGY. New York: Avenel Books, 1978.

Campbell, Joseph. THE MASKS OF GOD: CREATIVE MYTHOLOGY. Viking Press, 1968.

A CHINESE BESTIARY: STRANGE CREATURES FROM THE GUIDEWAYS THROUGH MOUNTAINS AND SEAS. Edited and translated by Richard E. Strassberg. The University of California Press, 2002.

Coleman, Loren and Jerome Clark. CRYPTOZOOLOGY A TO Z. Fireside, 1999.

Coleman, Loren and Patrick Huyghe. THE FIELD GUIDE TO BIGFOOT AND OTHER MYSTERY PRIMATES. Anomalist Books, 2006.

DICTIONARY OF WORLD MYTH: AN A-Z REFERENCE GUIDE TO GODS, GODDESSES, HEROES, HEROINES AND FABULOUS BEASTS. General Consultant: Roy Willis. Duncan Baird Publishers, 2000.

DUNGEONS AND DRAGONS MONSTER MANUAL CORE RULEBOOK III v.3.5. Renton, Wash.: Wizards of the Coast, 2003.

FAIRY AND FOLK TALES OF THE IRISH PEASANTRY. Edited and selected by William Butler Yeats. New York: Dover Publications, 1974. (Reprint of original work published by Walter Scott, London, 1888.)

Flaubert, Gustave. THE TEMPTATION OF SAINT ANTHONY. Modern Library Classics, 1992.

Fort, Charles. THE COMPLETE BOOKS OF CHARLES FORT. New York: Dover Publications, 1974.

Greer, John Michael. MONSTERS. Llewellyn Publications, 2001.

Homer. THE ODYSSEY. Translated by Richmond Lattimore. Harper & Row, 1965.

James, Peter and Nick Thorpe. ANCIENT MYSTERIES. New York: Ballantine, 1999.

Jung, C. G. THE ARCHETYPES AND THE COLLECTIVE UNCONSCIOUS. Translated by R. F. C. Hull. Princeton, N.J.: Bollingen, 1990.

Keel, John A. DISNEYLAND OF THE GODS. New York: Amok Press, 1988.

Levy, Joel. A NATURAL HISTORY OF THE UNNATURAL WORLD. Thomas Dunne Books, 2000.

Mack, Carol K. and Dinah Mack. A FIELD GUIDE TO DEMONS, FAIRIES, FALLEN ANGELS AND OTHER SUBVERSIVE SPIRITS. Owl Books, 1999.

Ovid. METAMORPHOSES. Translated by Mary M. Innes. Middlesex, England: Penguin Books Ltd., 1955.

Page, Michael and Robert Ingpen. ENCYCLOPEDIA OF THINGS THAT NEVER WERE. New York: Studio Books, 1998.

Pliny the Elder. HISTORIA NATURALIS. Translated by Joyce Irene Whalley. Sidwick & Jackson, 1982.

Radford, Benjamin and Joe Nickell. LAKE MONSTER MYSTERIES. University Press of Kentucky, 2006.

Rose, Carol. GIANTS, MONSTERS, AND DRAGONS: AN ENCYCLOPEDIA OF FOLKLORE, LEGEND, AND MYTH. New York: WW Norton & Co., 2000.

Sedgwick, Paulita. MYTHOLOGICAL CREATURES: A PICTORIAL DICTIONARY. Henry Holt & Co., 1975.

Virgil. THE AENEID. Translated by W. F. Jackson Knight. Middlesex, England: Penguin Books Ltd., 1956.

Warner, Marina. NO GO THE BOGEYMAN: SCARING, LULLING & MAKING MOCK. Farrar, Straus and Giroux, 1998.

## WEB SITES.

http://www.abdn.ac.uk/bestiary

http://www.beastofbrayroad.com

http://www.cryptozoology.com

http://fantastic-library.cornell.edu/

http://www.godchecker.com/pantheon

http://www.newanimal.org

http://www.occultopedia.com

http://www.pantheon.org

http://www.prairieghosts.com

http://www.skell.org/explore/mythad.htm

http://www.theoi.com

http://www.uiowa.edu/borges/english.shtml

http://www.unknown-creatures.com

http://www.wikipedia.com

UNFLOWN (&) UNKNOWN